ARTE POVERA

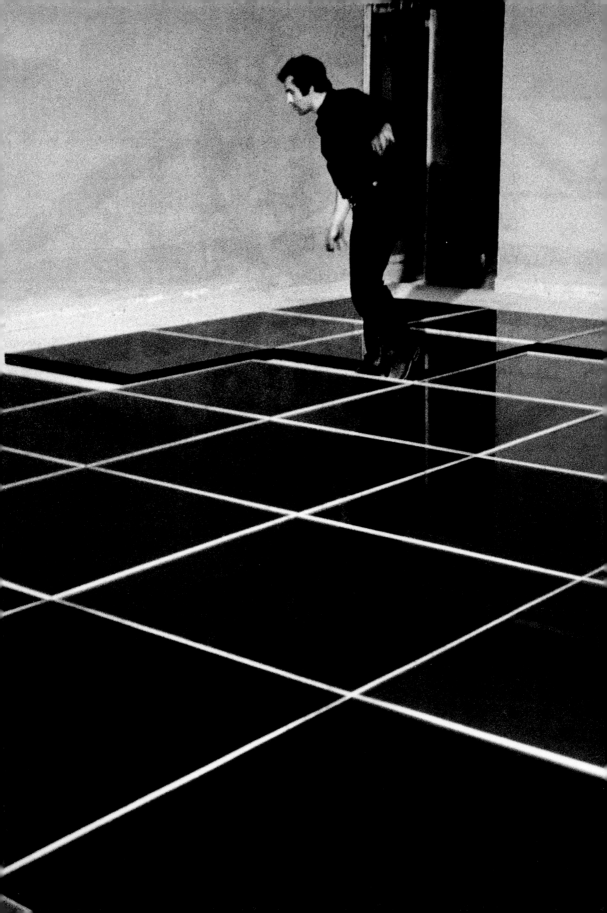

ARTE POVERA

ROBERT LUMLEY

TATE PUBLISHING

Published by order
of the Tate Trustees
by Tate Publishing
a division of
Tate Enterprises Ltd,
Millbank, London
SW1P 4RG
www.tate.org.uk/
publishing

*British Library Cataloguing in
Publication Data*
A catalogue record for
this book is available
from the British Library

ISBN 1 85437 588 1

Distributed in North
America by Harry N.
Abrams Inc., New York

Library of Congress
Control Number:
2004111333

Cover designed by
Slatter-Anderson,
London
Book designed by
Isambard Thomas
Printed in Hong Kong
by South Sea
International Press Ltd

Cover:
Michelangelo Pistoletto
Monumentino (Little
Monument) 1968
(fig.47)

Frontispiece:
Pino Pascali
*32 square metres of sea,
approx.* 1967
(detail of fig.4)

Measurements are given
in centimetres,
height before width,
followed by inches in
brackets

For Clare

ACKNOWLEDGEMENTS

I would like to start by thanking the artists who
generously talked about their work with me:
Giovanni Anselmo, Luciano Fabro, Piero Gilardi,
Jannis Kounellis, Giulio Paolini, Giuseppe Penone,
Gianni Piacentino, Michelangelo Pistoletto and
Gilberto Zorio. Friends in Italy who have given me
valuable help and advice: Marcello Levi, Antonio
Tucci Russo, Tommaso Trini, Mirella Bandini,
Maria Teresa Roberto, Cristina Mundici, Virginia
Bertone, Sandra Furlotti and Paolo Mussat Sartor.
For hospitality in Valle Buontempo, Marco
Buttino and Sandra Cavallo. Colleagues and
friends in London: Giorgia Bottinelli, Briony Fer,
John Foot, Francesco Manacorda, and Joy
Sleeman. Richard Flood and Frances Morris who
gave me a great break. Alma Ruiz who helped me
with a more global view of Arte Povera. Katherine
Rose for her scrupulous editing, Alessandra Serri
for the picture research and Emma Woodiwiss for
production. And, lastly Laurence and Matthew,
who became young fans of Arte Povera, and Clare
to whom this book is dedicated.

Contents

I

1
Alighiero Boetti
Manifesto 1967
Red print on filing
paper
70 × 100 (27½ × 39¾)
Collection Alessandro
Riscoassa, Turin

MOVEMENT AND CRITICISM

TWO MANIFESTOES

At the end of 1967 Alighiero Boetti produced a work entitled *Manifesto*, a poster
printed in yellow, rose, green and white (fig.1). He sent most of the 800 copies
to fellow artists as well as other figures on the Italian art scene, the remainder
being sold later in a signed and numbered edition. In Italian the noun *manifesto*
can mean 'poster' or 'billboard'; equally, it can mean 'manifesto' in the sense of a
public statement, as in Futurist Manifesto. The adjective *manifesto*, meanwhile,
can be variously translated as 'manifest', 'apparent', 'obvious', or as 'notorious'
and 'well-known'. But Boetti's *Manifesto* deliberately set out to frustrate
expectations of transparency, explicitness and direct public communication in
favour of opacity, ambiguity and the adoption of a highly private, indeed
secret, code that only he could decipher. The list of names to the left would
have been instantly recognisable to the recipients of the poster as those of
young Italian artists, some well-known (like Michelangelo Pistoletto), others
less so. Boetti placed his own name towards the middle. However, an air of
intrigue and enigma hovers over the work thanks to eight curious signs that are
Boetti's invention, aligned in a variety of combinations to the right of the
names. There was a way to find out what they meant – a notary was apparently
charged by Boetti to show the code when requested on payment of a sum of
money. Whether or not this notary actually existed is subject to conjecture.
Nobody (as yet) has seen the code. In consequence, one can only speculate on
the properties that Boetti ascribes to the artists as individuals, as subsets of the
group, and as names on the list as a whole. As if to help solve the mystery,

PAOLINI

FABRO

GILARDI

PIACENTINO

NESPOLO

ZORIO

PISTOLETTO

BOETTI

SIMONETTI

KOUNELLIS

CEROLI

PASCALI

ICARO

MONDINO

MERZ

SCHIFANO

Alighiero Boetti 48/50
Tipografia MANIFESTI - Via G. Assalino, 2 - TORINO (1893) BOETTI

Boetti produced a second work based on the first in which he is photographed making gestures in front of each name in turn, including his own (fig.2). Yet the ambiguity of the sign and body language, along with the total absence of verbal clues, merely adds another layer of possible meanings to those already imagined.

In November 1967 another 'manifesto' appeared in the form of Germano Celant's 'Arte Povera: Notes for a Guerrilla War', published in the magazine *Flash Art*. The article was not officially a manifesto but bore all the hallmarks of the genre. It drew up battle-lines between a new kind of art and the art that was identified with 'Op, Pop and primary structures'; on the one side there were artists who embodied free creativity and a 'new humanism', on the other, the representatives of 'the system' with their conformism to the dictates of technology and assimilation of 'codified and artificial languages'. The rhetoric is marked by either/or dichotomies and the use of hyperbole. The manifesto begins 'First came man, then the system', and, after some initial general statements, the main part of the article presents the work of some twelve

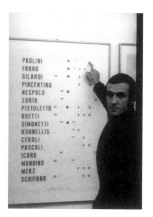 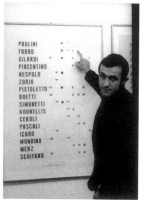 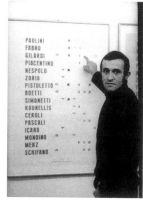 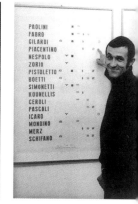

artists under the rubric of 'Arte Povera'. The argument is made that there is a broad convergence between the individual projects of these artists, whether it is the idea of tautology in the work of Luciano Fabro, the use of gestural archetypes by Boetti, or the precariousness and instability of the objects created by Mario Merz and Gilberto Zorio. The other artists discussed (identified by surname only) are Pistoletto, Anselmo, Piacentino, Gilardi, Prini, Kounellis, Paolini and Pascali. At the last minute, Celant adds further names of those 'who share this attitude': Alviani, Scheggi, Bonalumi, Colombo, Simonetti, Castellani, Bignardi, Marotta, De Vecchi, Boriani, Mondino and Nespolo. The manifesto ends with the words: 'No sooner has this text been written than it will be full of holes. We are already in the middle of a guerrilla war.'

The juxtaposition of these two 'manifestoes' might seem strange, even inappropriate. Boetti's *Manifesto* is a piece of art in the tradition of Francis Picabia's *The Cacodylic Eye* 1921, a canvas onto which visitors (mostly fellow artists) added something and then signed their names. Celant's article is the product of a critic writing in the tradition of the twentieth-century

manifestoes that proclaimed the launching of new movements, from the Futurist Manifesto of 1909 onwards. However, there are good reasons for taking them together as the starting-point for this essay on Arte Povera. Firstly, the two manifestoes were produced within weeks of one another at a time when the artist and critic were collaborating very closely. In October 1967 Celant included Boetti's work in the group show *Arte Povera – IM Spazio*, which inaugurated the cycle of Arte Povera shows and introduced the idea of 'poor art'. Then, in December, Celant curated a solo exhibition of Boetti's work at the same gallery in Genoa, writing an accompanying catalogue essay. Whether *Manifesto* was a semi-critical response to Celant's theorising is not clear. Whatever the case, both manifestoes evoke a strong sense of a community of artists, even if what brings these artists together is not necessarily obvious to all concerned. Secondly, the two manifestoes belong to the same broad tradition of the avant-garde in which artworks, often using words, coexisted with and implicitly commented on the public proclamations of the group or movement. Thirdly, the two texts read side by side highlight the problem of what Umberto

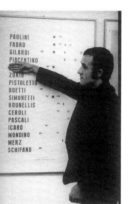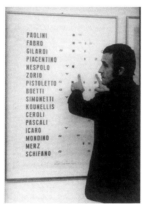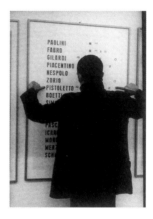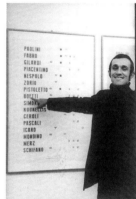

Eco has referred to as 'open work', by which he meant openness to interpretation (Eco, 1962/1989). While Boetti's poster exemplifies a bewildering open-endedness in this respect, it would be wrong to see Celant's manifesto as unequivocal. It was a response to an ongoing discussion among artists and critics, and its provisional, even improvised character, is openly acknowledged: 'no sooner has this text been written than it will be full of holes.'

NEO-FUTURISM?

The launching of Arte Povera in September 1967 seemed reminiscent in some ways of the promotion of Futurism, arguably the only real Italian avant-garde movement to have dominated the visual arts domestically as well as internationally. F.T. Marinetti, poet, ideologue and inspired publicist, had set out an agenda that consisted of nothing less than revolutionising life and art. Echoes of Futurism were already in the air in the late 1960s, especially among young artists in Rome. The very title and graphics of the watershed group exhibition *Fuocooooooooo, Imagine, Accqqua, Terrrrrrra* at Fabio Sargentini's Attico

gallery in August openly alluded to it as a precedent, while the critic Maurizio Calvesi discussed the emergence of a second avant-garde that would pursue the experimentation with materials and energy begun by Giacomo Balla and his fellow Futurist artists. Celant even considered the name 'Neo-Futurismo' before opting instead for the term 'Arte Povera'. Futurism's free use of different techniques and media from painting and sculpture to film, theatre and music, anticipated Arte Povera's radical practices. However, the relationship to Futurism is better conceived in terms of analogy rather than influence. There are striking analogies between the circumstances in which Futurism and Arte Povera arose.

Italy's post-war 'Economic Miracle' recalled the industrialisation and urbanisation of the early years of the twentieth century in Italy when the Fiat motor company was founded in Turin and the cities of the North expanded rapidly. The automobile was, in fact, a key symbol of the miracle. Between 1961 and 1968 some 9,710,000 vehicles were produced, and the number of cars made in 1968 alone was equivalent to all the cars on the road in Sweden. These and other statistics were piled high in the celebratory volume *Torino Metropoli d'Europa* (1969) published by the city's industrialists. It greeted the dawn of a new epoch:

Today, flying into the airport the view from the sky might be less poetic than that of the seventeenth-century city, but it represents an equally fascinating image of the civilisation in which we live; the points of reference of its urban geometry have become the grid of unmistakable monuments, the monuments of labour typical of Turin – the automobile factories.

In Milan, Gio Ponti's Pirelli tower became synonymous with the new Italy, a skyscraper in the American manner but with the architectural and design flair for which the Italians were making their name. For Reyner Banham, writing at the time, it was 'one of the most important buildings in Europe', a confident affirmation of the principles of Modernism. This influential critic, whose *Theory and Design in the First Machine Age* of 1960 celebrated the achievements of Futurism, later looked back on the 1960s as 'what appeared to be a second machine age as glorious as the first', a time when 'miniaturisation, transistorisation, jet and rocket travel, wonder drugs and new domestic chemistries, television and computers seemed to offer more of the same, only better. What had been promised by the First Machine Age but never properly delivered, now seemed to be at hand' (Banham, 1999, p.10).

Arte Povera was, therefore, the product of an advanced industrial country. Significantly, the majority of the artists were based in the northern cities of Turin, Milan and Genoa. However, the emergence of what the economist Kenneth Galbraith called the 'affluent society', the new economy driven by consumption, was not experienced in the same way in Italy as in the United States. It is symptomatic that, in the Italian visual arts, Pop was promoted by galleries and bought by wealthy collectors, but the works were largely imports. In an article of May 1964 in the design magazine *Domus*, Ettore Sottsass Jr discussed whether the Turin artist Pistoletto was or was not a Pop artist – at the time he was exhibiting at the Sperone gallery in Turin alongside Jim Dine, Roy

Lichtenstein, Claes Oldenburg, Robert Rauschenberg, James Rosenquist, Andy Warhol and Tom Wesselmann. Sottsass had just witnessed the triumph of these American Pop artists on a visit to New York. While acknowledging that Pistoletto did represent everyday life and used photography for his 'mirror paintings', he concluded that his work belonged to a different reality and a different tradition: 'in Italy the preconditions for becoming a Pop artist do not exist. There is none of the hard-sell that comes with Coca Cola, no post-cowboy violence, little birth-control, little use of deodorants, and *boules* is still played.' (Lumley, 2000, p.174) For Sottsass, Pistoletto belonged to a European tradition steeped in the anguish of solitude that stretched from the novels of Franz Kafka through Fritz Lang's *Metropolis* to the films of Michelangelo Antonioni. Despite his fascination with America, he expressed his hope that its cultural model would never be transplanted to Italy.

The optimistic belief in economic and social progress in the first half of the decade, began to founder in the second. There was growing awareness of the costs of the economic growth at home and increasing political polarisation internationally. Mass migration from the countryside destroyed the 'peasant civilisation' described in 1946 in Carlo Levi's *Christ Stopped at Eboli*. Pier Paolo Pasolini denounced the 'anthropological' transformation of the population and what he saw as the domination of a culture of conformity in a series of films, from *The Gospel According to Matthew* 1964 to *Theorem* 1968. On the international scene, the escalation of the Vietnam war provoked waves of protest. The kind of critical 'European' attitude to the American mainstream found in Sottsass's remarks was now given a political charge by a younger generation that could identify with Beat culture but otherwise linked America with economic materialism, worship of technology and imperialism. In the winter of 1967, the student movement started to mobilise, occupying universities and high schools throughout Italy in 1968. The following year massive strikes by industrial workers climaxed in the so-called 'Hot Autumn'.

Arte Povera, like Futurism, thus took shape in circumstances of dramatic socio-economic change and political conflict in which the spirit of drastic reform coincided with the desire for a *tabula rasa* and the subversion of conventions in art as well as society. However, if Futurism was largely associated with protest that was ultra-nationalist and anti-egalitarian – its exponents enthusiastically supported Italy's entry into the First World War – Arte Povera was formed in the context of a rising tide of anti-war sentiment, internationalism and libertarian socialist ideas. If Futurism romanticised the machine age and its vision of the future, Arte Povera espoused a radical scepticism towards technology and modernist utopias. If Futurists advocated the wholesale rejection of Italy's artistic heritage, museums, monuments and everything cursed by the dead hand of age and tradition, the Italian artists of the 1960s were altogether more pragmatic, eclectic and ready to look back to the past.

The grand narrative of twentieth-century art history is dominated by movements (as this very series of books confirms). In the 1960s a proliferation of new trends appeared, from Nouveau Réalisme in Paris to the Pop art and Minimalist currents in the United States. While Pierre Restagny's role in

promoting Nouveau Réalisme showed the possibilities open to the enterprising critic, the impact of the American movements was perceived as a threat by many Italians. When Robert Rauschenberg won the First Prize for Painting at the Venice Biennale in 1964, it sent a shock wave through the art world in Italy. For young and open-minded critics like Celant, the new American art called for a European response. Well versed in art history and fascinated, along with many of his generation, in the early avant-garde, Celant made a conscious decision to organise artists into an equivalent group or tendency. For their part, the artists had everything to gain and nothing to lose. In other words, there was a good dose of pragmatism in the reasons for establishing the Arte Povera grouping, a characteristic that was to mark its subsequent evolution. Contrary to the impression given by 'Notes on a Guerrilla War', Arte Povera was less a movement in the strong sense than a loose grouping or confederation of artists, less a programme than a series of working hypotheses to be investigated.

The term 'neo' was often added as a prefix to the movements that emerged at this time (as in *neoavanguardia*, an experimental literary movement whose exponents included the poet Nanni Balestrini and the critic Umberto Eco). This context of revisiting previous artistic trends helps to explain the high degree of reflexivity in Arte Povera, and its awareness of historical precedent. Emblematic in this respect is a work by Giulio Paolini, one of the artists included in the first Arte Povera exhibition. *174* (fig.3) is a panel of hardwood on which is stuck the blown-up photograph of page 174 of an art book, in which a diagram outlines the development of art movements from 1960 to 1965 (the date of Paolini's work). In Paolini's words,

3
Giulio Paolini

174 1965

Wood-mounted photograph and card
150 × 120 (59 × 47¼)
Galleria Civica d'Arte Moderna e Contemporanea, Turin. Donated by Eugenio Battisti

4
Pino Pascali

32 square metres of sea, approx. 1967

Aluminium, water and aniline dye
30 containers, each
6.5 × 110 × 110
(2½ × 43¼ × 43¼)
Galleria Nazionale d'Arte Moderna, Rome. Gift of the Pascali Family

the intention was to 'give the picture its precise and historical measure: thus the picture is the extreme physical limit of the diagram it reproduces' (Celant, 1972, p.45). Reflexivity and historical consciousness gave a greater role to irony and linguistic play than to strategies of negation. Celant's role had more in common with that of a mediator and facilitator than that of a charismatic leader like Marinetti.

DEFINING ARTE POVERA

Between the first group show of September 1967 held in Genoa and the last one of June 1971 in Munich, Arte Povera was continuously redefined in both the critical statements and the artwork produced, while the boundaries according to which artists were included shifted dramatically. It is indicative of this that only two artists – Boetti and Prini – were present in all the group shows, and that by 1969 what had been an all-Italian group had been stretched to include Americans and North Europeans under its umbrella. The whole business of labelling was fraught with difficulties, not least because the artists themselves

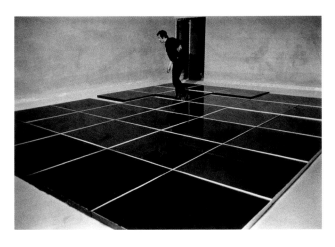

resisted such categorisation. For instance, in a humorous comment written over an image and included in Celant's book *Arte Povera* of 1969, Pistoletto declared: 'Dear Germano, the word poor is fine, the word rich is fine, but I poor and you rich is not fine, you poor and I rich is not fine' (Celant, 1969, p.19). Tommaso Trini, gallery critic of *Domus*, who had followed developments closely from the early 1960s, commented: 'Now it seems that the new artists have managed it: no more labels ... In the last two years there have appeared on the international scene the results of an artistic process that has so far rejected all attempts at narrow definition'.

The initial conceptualisation of Arte Povera referred exclusively to art practices and their relationship to everyday life. Furthermore, its scope was primarily linguistic. Following the approach of Jerzy Grotowsky, the celebrated exponent of 'poor theatre' (Grotowsky, 1991), Celant wrote: 'The linguistic process consists now in taking away, eliminating, downgrading things to a minimum, impoverishing (*impoverire*) signs to reduce them to archetypes. We are in a period of de-culture. Iconographic conventions fall and symbolic and conventional languages crumble' (Christov-Bakargiev, 1999, p.221). It is worth noting that this definition does not refer to materials, unless as a vehicle for language. Arte Povera here is, above all, anti-mimetic. It counterposes banal presentation with representation. It reduces signs and gestures to their archetypes. Thus the opening paragraph enumerates a series of unremarkable facts and events only to announce in the second paragraph that they are examples of the new art: 'Nothing happens on the screen, a man sleeps for

twelve hours; there is nothing on the canvas, just canvas itself or its frame; the sea is made of blue water ... These observations describe a film by Warhol, a canvas or a picture by Paolini; a sculpture by Pascali' (see fig.4).

It is worth noting, meanwhile, that poverty here does not carry the associations with deprivation or moral stigma that it often does within Protestant cultures. Instead, the word *povero* carries a certain dignity associated in Catholic cultures with the figure of St Francis. While Celant's usage does not specifically allude to such connotations, and is thoroughly modern and secular in intention, the word in Italian nevertheless has a strongly positive as well as negative resonance, something that is lost when Arte Povera is translated literally as 'Poor Art'.

The first show, *Arte Povera – IM Spazio* of September 1967, which grouped together only six artists (Boetti, Fabro, Kounellis, Paolini, Pascali and Prini)

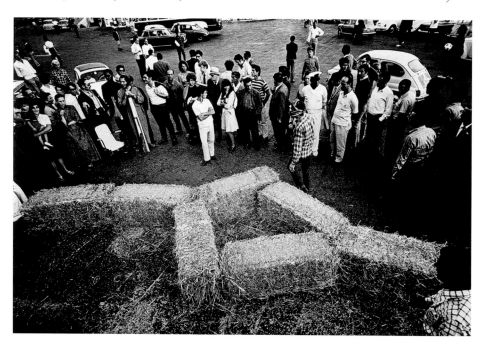

used the term tentatively as a hypothesis. Within a month or so, however, Celant published his 'Arte Povera: Notes for a Guerrilla War' and in this 'manifesto', as has been seen, the subversion of linguistic conventions was coupled with a political critique of technology and capitalist society. In Bologna, at the second Arte Povera exhibition in February 1968, six more artists were added to the exhibitors. At Amalfi in October, Celant curated three days of artistic experimentation under the rubric *Arte Povera + Azioni Povere*, in which 'actions' took place in parallel with the exhibition of artworks. Invited artists included Richard Long, Jan Dibbets and Ger Van Elk as well as Italians not involved in earlier shows. The event marked a turn towards what at the time the critic Lucy Lippard called 'the dematerialisation of the art object' (Lippard, 1997). The period of making objects, of trying to 'materialise sensations, ideas and energies in objects', was declared over. Instead, the artists were now engaged

in *azioni povere* that 'leave no usable or exploitable trace. They no longer last as objects, but occur as varied and continuously changing episodes' (Christiv-Bakargiev, 1999, p.224). Celant was referring to art practices that subverted the commodity form and mechanisms of the market, and overcame the barriers dividing 'art' and 'life'. Any number of actions at Amalfi seemed to bear this out, from Richard Long shaking the hands of passers-by to Paolo Icaro repairing the corner of a building, and Gino Marotta creating a garden in the piazza with bales of hay (fig.5).

In 1969 20,000 copies of Celant's book *Arte Povera* (fig.6), issued in English and German translation as well as in Italian, were published to coincide with the big survey shows held in Copenhagen and Basel at which American artists joined their European contemporaries. It included documentation of works by American artists such as Walter De Maria, Eva Hesse, Robert Smithson, Robert Morris and Joseph Kosuth, alongside those who had already exhibited in the shows in Italy. The book emphasises the 'discovery' of the natural world: 'the artist draws on the substance of natural events, such as the growth of a plant; the chemical reaction of a mineral; the behaviour of a river, snow, grass and earth; or the fall of a weight. He identifies with them in order to experience the astonishing organisation of living things' (Christov-Bakargiev, 1999, p.198). The significance of materials is underlined from the opening words: 'Animals, vegetables and minerals have cropped up in the art world. The artist is attracted to their physical, chemical and biological possibilities' (Ibid. p.198).

5
Gino Marotta's untitled work made from bales of hay in Amalfi in 1968, photographed by Claudio Abate

6
Cover of the Italian edition of Germano Celant's 1969 book *Arte Povera*

In part, Celant's redefinition of Arte Povera was influenced by the writings of the American philosopher John Dewey, who promoted anti-rationalist processes and encouraged forms of thinking that brought emotions to the fore. Celant makes direct reference to Dewey in *Arte Povera*: 'Among other things the artist discovers himself, his body, his memory, his movements, everything that lives directly, and thus begins again to experience the meaning of life and nature, a meaning that implies, according to Dewey, the sensory, the sensational, the sensitive, the sensible, the sentimental and the sensuous' (Christov-Bakargiev, 1999, p.26). But Celant was also responding directly to the work of the artists of the 'second wave' (mostly attached to Sperone's gallery in Turin), who had joined the others at the Bologna show, notably Giuseppe Penone, Giovanni Anselmo, Gilberto Zorio and Mario Merz.

Celant interpreted his role as critic in terms of 'being at the side of the artists', rather than detached from them. This meant a continuous dialogue in

which his task was to interpret and articulate their intentions, not to impose definitions from the outside or to assume the superior position of the traditional intellectual. Very often Celant's statements echo and paraphrase those of the artists. As a curator, he would ask the artists to select and install work for exhibition themselves, keeping his own interventions to a minimum. Tommaso Trini later commented that Celant was a kind of 'acritical critic'. Seth Siegelaub, who was pioneering new forms of exhibitions and catalogues with American Conceptual artists at the time, quipped, in a recent interview with the author, that Celant was 'the only Italian person in the history of art who has replied to a letter'. A remarkable organisational talent certainly drove the plethora of projects and initiatives that helped put Arte Povera on the map. Born in 1940, Celant was still young and relatively inexperienced at this point, but he quickly took advantage of the relative freedom enjoyed by freelance curators in Europe, who as Thomas Crow notes 'tirelessly work through commercial galleries and public museums as opportunities present themselves' and who 'discover, group and advance their chosen artists in service of an argument about the needs of art and the state of the culture' (Crow, 1996, p.145).

Despite the efforts of Celant and other critics, Arte Povera was quickly identified with materials, and this identification became a shorthand way of describing the art. In fact, when in 1970 Jean-Christophe Ammann of the Kunstmuseum in Lucerne approached the artists about a group show, they rejected the name 'Arte Povera', 'because in a literal sense it refers to only one aspect of their work as the material is only the means towards the message' (Christov-Bakargiev, 1999, p.226). Instead, Ammann proposed the title *Processi di pensiero visualizzati* (Visualised Thought Processes) and came up with the following definition: 'Arte Povera designates a kind of art which, in contrast to the technologised world around it, seeks to achieve a poetic statement with the simplest of means. The return to simple materials reveals laws and processes deriving from the power of the imagination, and is an examination of the artists' own conduct in an industrialised society' (Ibid. p.226). Had Arte Povera been defined solely by the way in which it widened the repertoire of materials available to art, its historical significance would have faded once that frontier had been extended. However, the current resurgence of interest in Arte Povera among artists as wells as curators, critics and art historians is closely related to the possibilities opened up by this astonishingly varied and inventive moment in Italian contemporary art. The difficulty lies in making sense of a phenomenon that was remarkable for the ways in which it combined freedom and freshness with a sophisticated exploration of the language of art.

Care also needs to be taken regarding Celant's formulations. Rather than seeing them as definitive statements, one should read them, as was intended at the time, as proposals, descriptions and hypotheses asking to be developed, criticised and, if necessary, abandoned. It is significant that Celant's style is wilfully disjointed and poetic in its evocations and use of metaphor. He was not without his critics at the time, and analyses of his texts by Bettina Ruhrberg have highlighted plenty of inconsistencies and contradictions. How was it possible for the 'presentation' of objects to be entirely separated from

'representation' and cultural associations? How could the work of an artist like Pino Pascali be treated as 'pre-iconic' when it used icons from the Baroque to Pop art with irreverent ease? Was Celant not projecting his own political ideas onto the art when he spoke of the abandonment of the object? Was it possible to have an art without objects? (Ruhrberg, 2001, p.22-32).

However, to demand, in retrospect, that Arte Povera should somehow have been more coherent and rigorous as a 'theory' is to ignore the way in which it deliberately jettisoned prescriptive approaches. The fact that the group survived in one form or another from 1967 to 1972 — a long time compared to many other twentieth-century movements — is also an indicator of the tolerance and eclecticism of its methods.

Some commentators have argued that this very lack of definition is reason for abandoning the category Arte Povera altogether. Dan Cameron, for example, has written that the Italian group was really a branch or derivation of an international movement whose centre of gravity was in America as illustrated in the work of Bruce Nauman, Eva Hesse and other post-Minimalist artists. Arte Povera was more the invention of an ambitious critic than a movement in its own right (Cameron, 1992). The problem with this approach is that it neglects the peculiar circumstances that made Italy a major centre of contemporary art in the 1960s. Firstly, Lucio Fontana, Piero Manzoni, Alberto Burri and Francesco Lo Savio had laid the bases for much of the art of the decade. Arte Povera, as will be seen, is inconceivable without the influence exerted by these predecessors, especially as far as the work of Fabro and Kounellis is concerned. Secondly, the evidence suggests that the group and collective dimension played a decisive part in the making of Arte Povera. The work was not produced by artists working in isolation. On the contrary, situations of intense dialogue and participation characterised the art scene in the second half of the 1960s, especially in Rome and Turin. It could be argued, indeed, that Celant's initiative capitalised on a situation in which extraordinarily innovative group shows were the order of the day, something not found in any other European country to the same degree at this time.

If it is accepted that Arte Povera is a useful category, there is still the danger of treating it as unproblematic and self-evident; as Mel Bochner warned when expressing his bewilderment in the face of accounts of Conceptual art, 'the way in which the field of artists is actually constituted at any given moment tends to be levelled by history. History has a way of making it all seem so preordained' (Newman, p.444). One challenge is to restore the element of instability and surprise that was experienced by contemporaries at the time. Another is to find patterns and meanings that can only be seen with the advantage of hindsight. The approach adopted in this essay is to shift between these two positions, and to explore the work of individual artists within the constellation of the group and in relation to themes that are particularly important for an understanding of Arte Povera. The aim, in the spirit of the manifestoes discussed at the beginning, is to provide an account in the hope that it will intrigue and stimulate conjecture, but in the knowledge that it will soon be 'full of holes'.

2

PLACE AND SPACE

The overlay and intersection of different geographies provided the context in which Arte Povera developed. At one level, there were intensely local communities of artists in Italy. Tommaso Trini spoke of the 'School of Turin', while the critics in Rome supported Pascali, Kounellis and other artists based in the city with, in Alberto Boatto's words, 'the fervour of football fans who when the players went on the field felt the overwhelming need to back the "local team"' (Lumley, 2001, p.49). Part of Celant's achievement was to hold together a grouping that was drawn from several cities: Turin and, to a lesser degree, Rome were the centres, but he also invited Emilio Prini from his home city of Genoa, Luciano Fabro from Milan, and Pier Paolo Calzolari from Bologna to participate in shows. This polycentric 'national' art scene was never separate, however, from wider European and transatlantic developments. Art centres in the peninsula had since the Renaissance developed in circumstances in which, according to Carlo Ginzburg: 'a relative ease of exchanges with faraway countries has been accompanied by limited and difficult communication with inland areas close by. Even today it is easier to go by train from Turin to Dijon than from Grosseto to Urbino'. But the velocity with which the Italian artists moved from a local circuit to exhibiting in America was unprecedented. Pistoletto's 'mirror paintings' and Gilardi's 'nature carpets' (fig.7) were the first to receive international exposure, thanks largely to the connection between the Sperone gallery in Turin and the Sonnabend gallery in Paris, but the relatively unknown Gilberto Zorio and Giovanni Anselmo were included alongside Eva Hesse, Bruce Nauman and Keith Sonnier in *Nine at Castelli*

curated by Robert Morris for Leo Castelli's gallery in New York in December 1968. Celant himself had a clear vision of the strategic importance of an internationalist approach at a time of remarkable convergence between the work of artists in America and Europe – a convergence celebrated in the now mythical survey shows of 1969: *Live in Your Head. When Attitudes Become Form* curated by Harald Szeemann in Berne, and *Op losse schroeven* (On Loose Screws) curated by Edy de Wilde and Wim Beeren in Amsterdam.

Part of the diversity of Arte Povera can be attributed to the geographical diversity of the artists' provenance. Critics, for example, have commented extensively on Kounellis's Greek origins, Penone's roots in the woods and fields of Garessio in Piedmont, and Pascali's Mediterranean identity. The risk, however, is to replicate ideas of authenticity and belonging as if they were given

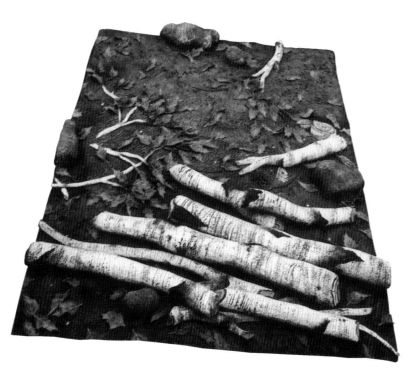

7
Piero Gilardi

Silver Birch 1967

Polyurethane foam
200 × 300
(78¾ × 118⅛)
Galerie d'Art Moderne,
Dunkerque. Courtesy
of Galleria Massimo
Minini, Brescia

and unproblematic categories – an explanatory shortcut that occurs in many critical accounts. The relationship of artwork to the world was (and is) far more complex and mediated, not least because the world had changed so dramatically in the industrial era, especially in the 1960s.

A good starting point for analysis is provided by Anthony Giddens' distinction between spatial relationships in premodern and modern societies:

In pre-modern societies, space and place largely coincided, since the spatial dimensions of social life are, for most of the population ... dominated by 'presence' – by localised activity ... Modernity increasingly tears space away from place by fostering relations between 'absent' others, locationally distant from [a] given situation of face-to-face interaction. In conditions of modernity ... locales are thoroughly penetrated by and shaped in terms of social influences quite distant from them. (Giddens, 1990, p.18)

The final destruction of premodern cultural forms in the 1960s, and the crisis of craft skills rooted in specific localities, created a widespread sense of loss that was shared by several of the Arte Povera artists. However, accounts that interpret Arte Povera as a set of craft-based art practices with a strongly romantic ethos overlook the complexity of the art. If it is true that Mario Merz developed a systematic critique of modernity that is expressed in his work, he was in many respects the exception rather than the rule. The response overall was more contradictory, and there were distinct variations according to artist. Emblematic in this regard is the answer given in the journal *Flash Art* in 1967 by Kounellis to an interviewer who was attempting to put him in a

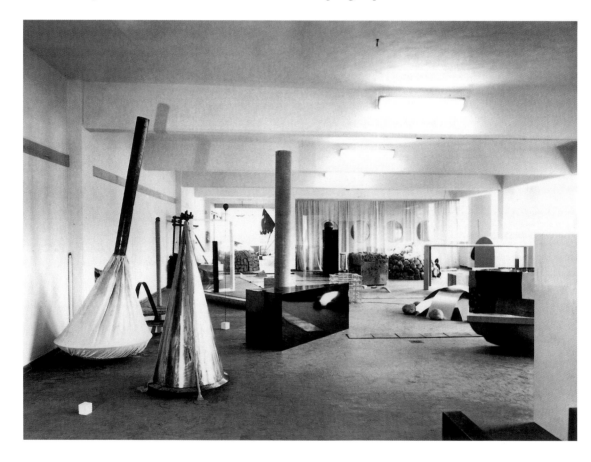

national pigeon-hole: 'As Mondrian said, the country of a painter is where he is working.' It was not that Kounellis was denying his Greekness but that he was asserting his freedom to define himself and his art without immediate reference to national frontiers.

For the artists, space and place were above all concerned with the relationship of the 'virtual space' of the work and the 'real space' of the gallery or site. In the second half of the 1960s this relationship underwent a series of radical transformations. The artwork changed in a number of respects as the traditional distinction between painting and sculpture gave way to hybrid

solutions, installations and mixed-media work. Ephemeral and time-based works also challenged the dominance of the fixed object. As Wim Beeren noted, 'an exhibition, too, should be no more – and, above all, no less – than a "situation"' (Beeren, 1982, p.54). The exhibiting spaces changed as galleries and museums accommodated the new art, leading to the conversion of industrial and commercial buildings (see fig.8) and the spread of the 'white cube' as the new gallery form. At the same time, the very definition of the space for art was expanded into the urban and wider landscape.

In the United States this revolution in the visual arts took the form of a systematic rejection of Modernism as it had been represented by the writings of Clement Greenberg and Michael Fried. In Italy there was no father figure or orthodoxy of an equivalent kind to oppose. Nor was there an Italian Minimalism. American Minimalism was known principally through magazines such as *Art News* and *Artforum*, in which the artists Donald Judd and Frank Stella expressed their dismissive views of what they saw as the dead traditions prevalent in contemporary European art. Yet the radical shifts in Italy followed a similar route. The Minimalist preoccupation with questions such as perception, the position of the viewer, and the need to bring art and life closer to one another, were all shared by their Italian contemporaries. When artists began to turn away from the Minimalist paradigm in America, a parallel development was taking place in Europe. But in Europe, as has been seen in Celant's 'manifesto', the artists initially saw themselves as challenging the dominance of the Americans, who were associated principally with Pop and Minimalist art.

The sections that follow deal with the theme of place and space in relation to specific areas of inquiry, and subdivide the artists accordingly. While the focus is on the artwork, information is given on the individual artists and the positions they occupied within the Arte Povera constellation. Differences as well as common preoccupations are examined. Four areas are identified: works by Luciano Fabro and Giuliano Paolini exploring sensory and optical relationships to space; the environments and *tableaux* created respectively by Pino Pascali and Jannis Kounellis; the metaphorical spaces of work by Mario Merz and Marisa Merz; and, finally, impeded mobility in Emilio Prini's installations.

PHENOMENOLOGY AND PERCEPTION: LUCIANO FABRO AND GIULIO PAOLINI

For Luciano Fabro, Arte Povera represented the possibility of continuing a dialogue with fellow artists and critics in which he had been engaged since his arrival in Milan from rural Friuli in 1959. While for some artists Arte Povera offered the opportunity to re-invent themselves (Mario Merz) or to exhibit for the first time (Emilio Prini), Fabro was already a recognised artist, respected for the precision and coherence that characterised his writings as well as his work. Milan in the early 1960s was the hub of an extraordinary experiment in contemporary art involving figures such as Piero Manzoni, Enrico Castellani and Lucio Fontana, and acting as a magnet for outsiders including Yves Klein and Francesco Lo Savio. These artists had cleared the ground and achieved a *tabula rasa* in works emptied of painterliness, expression and representation.

8
Installation view at an exhibition, Deposito d'Arte Presente, 1968

21

With the tragically premature deaths of both Manzoni and Lo Savio in 1963, Fabro represented the link between this situation in Milan and the newly emerging art scene centred on Rome and Turin. When he participated in the first Arte Povera exhibition he did so as someone who had helped to articulate the ideas that Celant interpreted. Central to these was a phenomenological approach to space, in which 'experience exists through time and in real space'. (Batchelor, 1997, p.25).

The problem of 'entering the work' or going beyond the picture frame was dramatically embodied for artists in Italy in the 1960s by the *bucchi* (holes) and *tagli* (slashes) of Lucio Fontana. For Fabro, Fontana was especially important because he opened up a line of research into *come inquadrare uno spazio* (how to frame a space). *Hole* 1963 (fig.9), a rectangle of glass silvered over like a mirror except for the transparent areas where Fabro had roughly painted on a protective paste, appears on its easel as a picture. Yet, as Fabro intended, viewers find themselves either looking through the work to the other side or looking at the fragmented reflections of themselves, made aware, above all, of the space surrounding them. This line of inquiry was outlined in a statement fictitously attributed to the late sixteenth-century English philosopher Francis Bacon that Fabro later selected for inclusion in Celant's book *Arte Povera*:

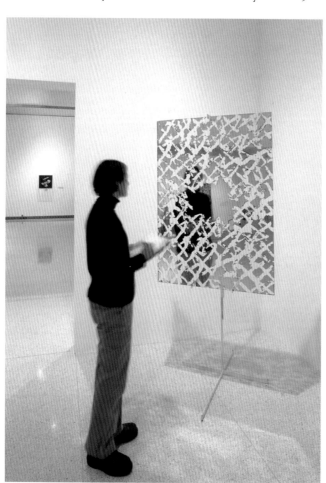

9
Luciano Fabro
Hole 1963
Glass, silver and lacquer, iron base
120 × 80 (47¼ × 31½)
Collection of the artist

10
Luciano Fabro
Pole 1965–6
Steel tube in two overlapping segments
Dimensions variable
Collection of the artist

My certainty is my sense for action.
That a new logic, concerned with the particular, may provide the means for developing the human spirit in the world.
To discover the order of things, and determine, so as to attain in an inert contemplation, their useful secondary properties, their modes of action, rather than their essences, and to induce the causes from the effects that make them felt.
To sharpen and order observation and reflection for this purpose. (Celant, 1969, p.84)

In a cycle of works made between 1964 and 1968, Fabro sought to objectify the subjective perception of space in such a way that the imperceptible (or the not-normally-perceived) became something that could be ordered, measured and laid bare. The citation of Bacon is not simply fortuitous. 'Analysis' and 'research' are terms that recur in Fabro's vocabulary at this time; his experiments, like that of Bacon's were empirical and eschewed *a priori* conceptions. Take *Pole* 1965–6 (fig.10). If the artist's instructions are followed, this slender tapering piece of metal is attached to the ceiling in such a way that it is a degree or two off the vertical and a few centimetres above the floor. *Cross* 1965 divides the room horizontally and vertically, leaving an arm's length to

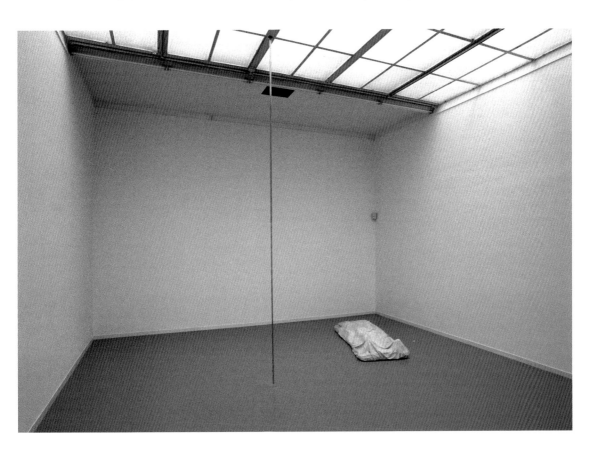

either side, and a gap of a few centimetres between it and the ceiling. These works heighten the viewers' perception of space, making them aware of the very existence of the floor, walls and ceiling through the most minimal of gestures (as if the objects themselves are pointing). The economy of means is remarkable. Viewers need know nothing about art or architecture or anything extraneous to that space. There is no trace of the artist or of craftsmanship in the metal structures. Yet, on entering a room the viewers find that the most mundane of experiences is rendered extraordinary. With *In cubo* 1966 (fig.11), a cube made of a wooden frame and white sheets, Fabro constructed the work with the viewer's physical proportions in mind. Catalogue photographs show

how visitors had to lift it from the floor in order to 'enter the work' and relate bodily to its geometry. Sounds in the surrounding space emphasise the activation of all the senses. For Fabro, this awakening of the senses was not merely physiological but had philosophical implications concerning 'being in the world'; he told his friend the critic Carla Lonzi: 'Taking possession of the world doesn't have an abstract value, but means opening a gap through which anyone who is disposed to can pass'. Art here involves heightening awareness through all the senses and is not just an object for contemplation by the detached spectator.

In the *Arte Povera* exhibition of September 1967 Fabro's contribution

consisted of a floor made of tiles. He gave instructions that it should be kept polished and covered with newspapers to prevent it from getting dirty. The work, entitled *Tautology*, consisted both in the action of polishing the floor and the maintenance of the effects of that action in the form of the newspaper. In Celant's words, it was the 'mundane and everyday entering the sphere of art' (Christov-Bakargiev, p.220). Nor was it by chance that he selected a menial task that was usually carried out by women in the home. His works with bed linen, *Three Ways of Arranging Sheets* 1968 (fig.13) and *The Baby* 1968, turn soft materials into gestures that evoke the feminine and maternal. They also reveal a sensuality that would later inform Fabro's opposition to what he saw as the reductiveness of some of Celant's formulations. With *Foot* 1968–71 (fig.12), Fabro seemed to turn his back on Arte Povera. This, in any case, was how the critic Saverio Vertone interpreted the work, seeing the use of rich materials such as silk, marble and bronze, and the elaborate craftsmanship as contravening 'the rejection of technique and the romantic cult of the gesture' that he identified with the 'anti-culture that has led contemporary art over the past two years' (Vertone, 1971, in de Sanna, 1996, p.60).

Giulio Paolini was also an established artist when he took part in Arte Povera, and like Fabro he was one of the 'theoreticians' with whom Celant was in dialogue after meeting him through Carla Lonzi, whose book *Autoritratto* (Self-Portrait) included extensive conversations with the two artists. (Lonzi's idea that the critic should *speak* with the artist in the form of interviews greatly

11
Luciano Fabro
In cubo (In Cube) 1966
Wood, canvas, chromium-plated iron
Dimensions variable
Collection of the artist

12
Luciano Fabro
Foot 1968–71
Portugese marble and silk
Dimensions variable
Musée des Beaux-Arts, Nantes

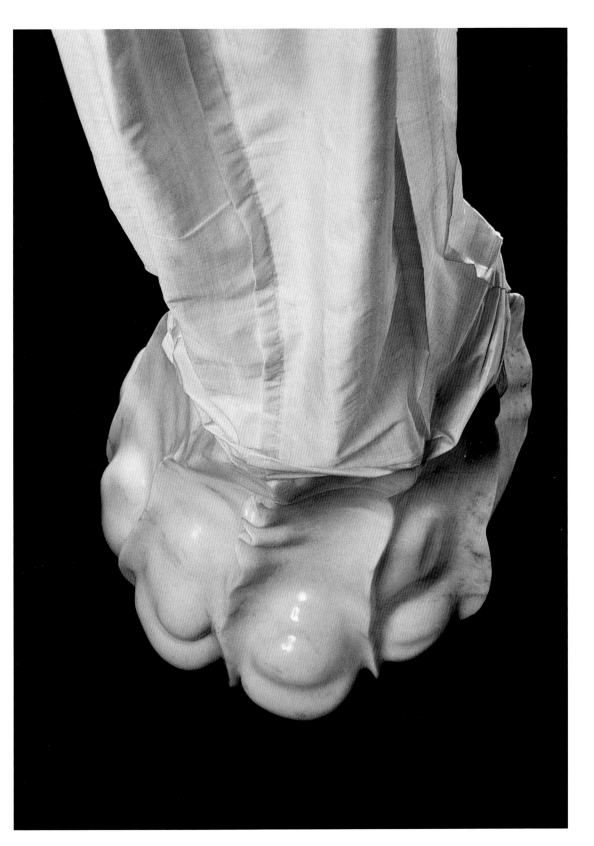

influenced Celant.) Paolini was based in Turin, but like Fabro exhibited at the Notizie gallery, not at the Sperone gallery where the majority of the local Arte Povera artists were represented. His work had most in common with the artists of the first phase of Arte Povera, with its investigation of art in terms of language and perception.

Paolini's oeuvre was distinctive in that he used the traditional materials of the painter to take apart the conventions underpinning art as a practice, as a body of artifacts and as an institutional discourse. Throughout the 1960s the

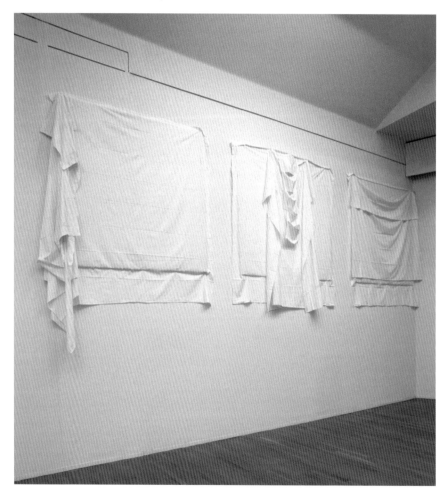

13
Luciano Fabro

Three Ways of Arranging Sheets 1968

Bed linen
Dimensions variable
Collection of the artist

work isolates and foregrounds the elements that make up painting, reversing the canvas or displaying the pot of paint to draw attention to the materiality of the means of representation. By systematically neutralising the ideas of originality or authenticity associated with traditional aesthetics, Paolini was also interpreting in visual form contemporary debates on the 'death of the author' initiated by Roland Barthes and the French structuralists, for whom the romantic idea of 'creation' had been superceeded by enquiries into systems and languages. As Anne Rorimer notes of *Delphi* 1965 (fig.14), 'by introducing his

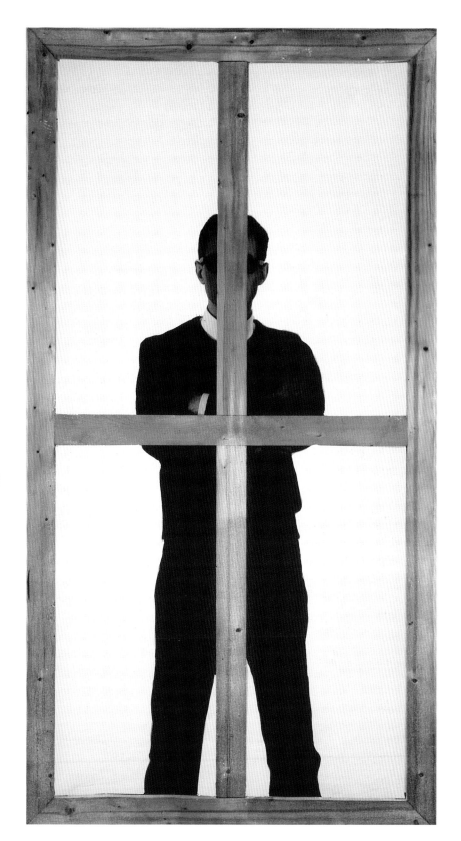

14
Giulio Paolini

Delphi 1965

Photographic
screenprint on canvas
182.9 × 97.8 × 0.75
(72 × 38½ × 2)
Walker Art Center
(Permanent Collection)

image into the work, Paolini paradoxically removes himself as subjective (and normally unseen) presence' (Rorimer 2001, p.65).

Paolini's tactic of reduction and simplification, however, served to restore sight, to make the act of seeing perceptible to the viewer. The viewer, in turn, becomes the author who completes the work. This is the marvel of Paolini's

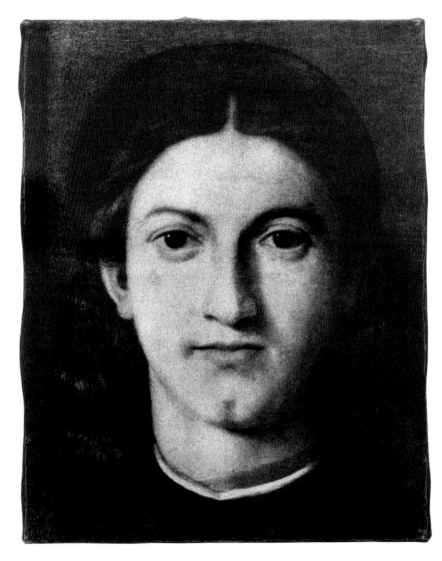

15
Giulio Paolini

Young Man Looking at Lorenzo Lotto 1967

Black and white photograph on paper
30 × 24 (11¾ × 9½)
Collection of the artist

Young Man Looking at Lorenzo Lotto 1967 (fig.15), a photograph of Lotto's *Portrait of a Young Man* of 1505. The mere change in title (itself an artistic convention) sets in motion a chain of thoughts: the original 'author' was also the first 'spectator' of the work; the young man is Paolini looking at a Renaissance portrait but he is also the object of the gaze of the man portrayed, as is Lotto himself. As Stephen Bann writes: 'Paolini has used the unique properties of the

photographic image to demonstrate that the visual never consists of a simple relationship between subject and object. The gaze is reversible. What we see sees us' (Bann, in Newman and Bird, 1999, p.177).

At the first Arte Povera show, Paolini placed white lacquered letters on the walls of a room in the gallery to spell *LO SPAZIO*, which can be translated either as 'the space' or as 'space'. The positioning of the letters ('at a mutual distance of one-eighth of the space's perimeter' (Celant, 1972, p.56)) made it impossible to read without simultaneously turning the head and body. The intervention was minimal. It drew attention to perception but through language and the act of seeing linked cognition to verbalisation. The total absence of colour emphasised the absence of expression, as did the use of cut-out lettering. Two years later Paolini exhibited *Four Identical Images* 1969 (fig.16), a work consisting of four indentical white canvases placed opposite one another

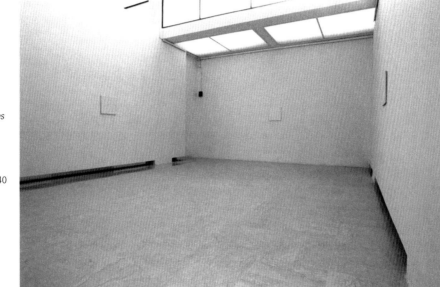

16
Giulio Paolini

Four Indentical Images
1969

Installation view with
three canvases
Pencil on canvas
4 pieces, each 40 × 40
(15¾ × 15¾)
Private Collection

on the four walls of the space. In his words, the canvases 'are only a vehicle to make one aware of the many others, so as to abstract from the canvases their own physicality and use their presence as an opening onto the infinite horizon of seeing' (Celant, 1972, p.85). It was this work that prompted the art historian Maurizio Fagiolo to ask: 'Is the *tabula rasa* a point of departure or a point of arrival?' (Fagiolo 1976, p.33). This question about the enigma of absence and emptiness summons up the ghost of the metaphysical painter Giorgio de Chirico, an artist not usually associated with Arte Povera: the canvas is not just a canvas.

Environments and Tableaux: Pascali and Kounellis
Pino Pascali, who was born in Bari in Southern Italy, studied Set and Theatre Design at the School of Fine Arts in Rome, where he lived and worked until his

death in a motorcycle accident in September 1968. With his magnetic sexuality, love of speed and precocious talent, he became the James Dean of the Roman art scene. Pascali was deeply imbued with the Neo-Dada and Pop influences that were prevalent in Rome in the first half of the 1960s. Early works included a pastiche of a Jasper Johns flag, and stretched canvases (reminiscent of works by Tom Wesselmann) forming female body parts, such as the erotic lips of *Homage to Billie Holiday* 1964–5. But Pascali was deeply critical of the civilisation that America represented. His opinions came across in the exhibition *Weaponry*, held at the Sperone gallery in Turin in 1966. On the one hand, the show was a

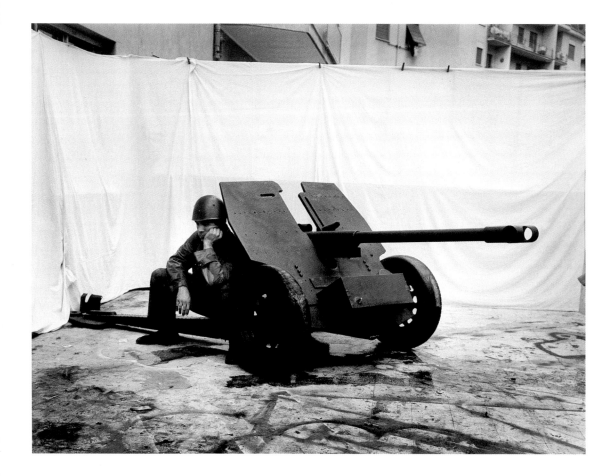

virtuoso exercise in Nouveau Réalist-style *bricolage*, in which the guns, missile-launcher and bomb seemed real but on closer inspection proved to be made of old car parts and plumber's tubing. On the other, the invasion and total domination of the gallery space by these simulated weapons took on a political connotation against the background of the escalating Vietnam War (fig.17). When Pascali himself, armed and dressed in camouflage, took up position amidst the weapons, he was actor, choreographer and designer of a deadly serious game.

Pascali's relationship to Arte Povera needs to be understood in this context.

His *One Cubic Metre of Earth* and *Two Cubic Metres of Earth* 1967 (fig.18), which were mounted on the gallery walls in the first group show, poke fun at the Minimalist structures of Donald Judd. The use of earth (by its nature formless, organic) undermines the clean geometry of the Minimalist cube. Floor pieces that make use of water, such as *Puddles* 1967 and *Sea* 1967, produce an analogous effect, but in this case the 'natural' fluid is placed in industrial aluminium containers. 'The sea is made of blue water – a sculpture by Pascali', wrote Celant, noting that the simple presence of the natural materials in the gallery indicated a convergence of life and art. 'If someone tells me "How beautiful"', said Pascali, 'it means nothing to me except the scoundrel with the flower in his lapel' (Lonzi 2001, p.153). This desire to rid art of talk about beauty and ugliness was a common theme in Arte Povera, as was the desire to go back to elementary gestures and signs. For Pascali, technologically advanced societies had lost touch with their inner humanity, a condition that he personally associated with childhood and primitive societies; in this sense, poverty was a precondition of creativity, not a state of deprivation ('it's the problem Italians, and Europeans, face; we need the intensity of someone who has nothing, to be truly able to create something') (op. cit., p.156). However, Pascali's relationship to Arte Povera was problematic in the eyes of

17
Pino Pascali

Cannone 'Bella Ciao' ('Bella Ciao' Field Gun) 1965

Metal, wood, wheels
150 × 450 × 130
(59⅛ × 177¼ × 51¼)
Collection Fabio
Sargentini, Rome

18
Pino Pascali

One Cubic Metre of Earth and *Two Cubic Metres of Earth* both 1967

Earth on wooden parallelepiped structures
Private Collection

many of his contemporaries. As the critic Renato Barilli noted at the time of the Bologna show of February 1968: 'Pascali deliberately moves at a "secondary" level of signs and symbols' (Lumley 2001, p.52). Subsequent accounts have underlined the anomalies between his position and that of the other members of the group. His art was hardly 'poor' in sense of stripped down, reduced or pre-iconographic. *Bridge* 1968, *Trap* 1968, animals such as the *Bristleworms* 1968 or *Blue Widow* 1968, or even the *Farm Tools* 1968, are semi-representational works that conjure up associations with Tarzan films, childhood fantasies and lost rural utopias. Pascali creates environments that are mythological fictions in which the artifacts play with their artifice: the *Bristleworms* (fig.19) were worm-like forms made with brushes of bright

synthetic fibres found in a hardware store, the cubes were only coated with earth, and the water in *Puddles* and *Sea* was coloured blue with aniline dye (see fig.4). The metamorphosis of banal objects and materials into creatures and environments was Pascali's way of re-enchanting the world and turning the labour of existence into the freedom of play.

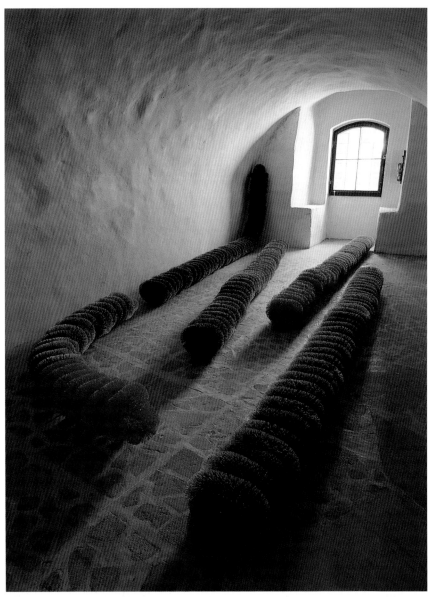

19
Pino Pascali

Bristleworms 1968

Acrylic brushes and foam rubber on metal support; 5 parts
Dimensions variable
Collection La Gaia, Cuneo

In 1968 Pascali helped Fabio Sargentini choose a new site for the Attico gallery, since the old space overlooking the Spanish Steps could not cope with the scale and ambition of the new work. The choice of a former underground garage for the new gallery anticipated a future trend in which disused commercial premises would be widely used as art spaces, while its use for the

projection of experimental films, dance and installations made it (along with the new Sperone gallery in Turin) a vital location for exhibiting the new art. It was inaugurated in January 1969 with Jannis Kounellis's *Untitled (Twelve Horses)* (fig.20), when, for three days, twelve live horses were tethered to the walls of the Attico. Pascali did not live to see it, but the event carried to an extreme conclusion the logic of his statement: 'I do not believe you make shows *in* galleries, you make the gallery, you create that space' (Lonzi, 1969, p.318).

Untitled (Twelve Horses) reveals an apparent paradox that is central to Kounellis's work: it is both radical and classical, 'demythicising' and 'remythicising'. Readings have, in fact, tended to one extreme or the other. At the time, the exhibition caused huge controversy and was taken as an insult to the public by a swathe of critical opinion. This reaction reinforced the notion that Kounellis was carrying out a necessary act of sacrilege in the face of bourgeois conceptions of art. It seemed to epitomise what was being advocated by *Flash Art*: 'everything must be torn down'. The very physical presence of the animals meant the invasion of base smells and sounds into the gallery, while absolute mimesis and the apparent absence of artistic intervention seemed to signal the extinction of art as creation. (As if to emphasise this, Kounellis played no part in choosing the horses or organising the *mise-en-scène*). On the other hand, *Untitled (Twelve Horses)* can be understood as a reprise of the classical iconography of equestrian statues and as the *tableau vivant* of an artist who thinks of himself above all as a painter. The horses, when exhibited, were remarkably motionless. They could be said to have heightened rather than diminished the aura surrounding the 'garage/gallery' space. Significantly, the work is known largely through Claudio Abate's photograph, the only image of the exhibition that the artist permits to be reproduced, even though the work has been re-enacted on two occasions — at the Venice Biennale in 1976 and at the Whitechapel gallery in 2002. The work exists, in other words, as a *tableau* whose 'uniqueness' is carefully maintained.

This radical innovation coupled with a reinvention of tradition is not exclusive to Kounellis. Arte Povera artists consciously abandoned the avant-garde's rejection of the past, favouring a more eclectic and open approach. Paolini, for example, is explicit in his art-historical references. However, Kounellis' oeuvre is marked by a strategic use of images and materials drawn from his experience of living in Greece until the age of twenty, when he left to study Fine Art in Rome. His is not principally the classical Greece of the Parthenon, but the contemporary Greece of dockyards and peasant farms. Piraeus, the port where he was born, would have been a place of corroded iron chains, hooks, sacks, crates, bales and cargoes stacked and piled. The reek of tar would have filled the air. The rural dwellings would have been built of stone with unused doors and windows blocked up with rocks and disused metal bed-frames propped against the wall. Looking at works made between 1967 and 1969 (fig.21), it is hard not to recognise their provenance in this world. As Tony Godfrey has noted, Kounellis' works can be classified as 'assisted readymades', a phrase coined by Marcel Duchamp to differentiate the totally unmediated 'readymade' found object from materials that have been reconstituted in some way by the artist (Godfrey, 1998, p.181). However, whereas 'Duchamp's work is

always cool, Kounellis leaves the objects and materials hot, mobile and uncertain'. With reference to the work consisting of fresh coffee on scales, *Untitled* 1969, Godfrey writes: 'Our reading of the work should derive from first-hand experience which must involve our own personal memories: it is not an illustration of something else' (ibid., p.180).

Celant commented that Kounellis opposed a 'popular language of the senses' to the 'elitist language of philosophy' (Ibid., p.180). The spectator is not able to assume a posture of detached contemplation, but is placed in the middle of the work. As in Pascali's installations, there is a strong theatrical dimension, but Kounellis departs radically from his fellow artist's mimetic approach. The 100 kilos of coal exhibited in the 1967 group show is real coal, the animals are real animals, the raw wool is real wool (fig.21). The 'reality effect'

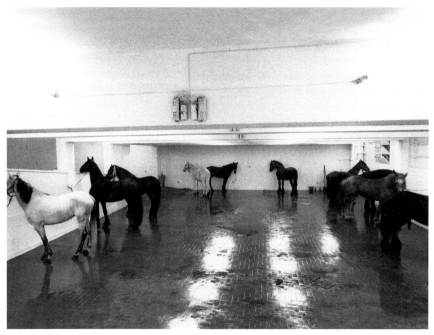

20
Jannis Kounellis
Untitled (Twelve Horses) 1969
Installation at Galleria L'Attico, Rome

21
Installation view showing various works in Jannis Kounellis's solo exhibition at the Galleria Gian Enzo Sperone, 1968

is not secondary but constitutive. At the same time, works by Kounellis are composed and ordered as if forming a still life in three dimensions, and can be compared to paintings by Giorgio Morandi as well as to Alberto Burri's works using sacking. Kounellis shifts the frontier of what can be defined as art, but there is never the idea that art should be dissolved into life. On the contrary, art is given a new meaning as a rite of initiation through which to re-experience life.

METAPHORS OF SPACE: MARISA MERZ AND MARIO MERZ

Marisa Merz was the only female artist to be treated as part of the Arte Povera group. Yet, although she had a solo show at the Sperone Gallery in June 1967 and at the Attico Gallery in 1969, she only participated in one Arte Povera exhibition, the Amalfi event. Moreover, she was not included in Celant's book *Arte Povera*. In an article in *Data* of June 1975, Tommaso Trini asked why

someone who had contributed in such a 'fundamental way' to the art of late 1960s should have been banished from its history. His answer was emphatic: 'Socio-cultural marginalisation has prevented her work getting the circulation and recognition in museums and in the art market.' It was not until feminism and shows such as Lea Vergine's pioneering exhibition on 'the other half of the avant-garde' (*L'altra metà dell'avanguardia* 1980) that women such as Merz got the wider critical attention they deserved.

However, could it be that Marisa Merz chose to opt out of the competitiveness of the art scene and the pressure of the art market? Her deliberate evasiveness in supplying biographical information (including her

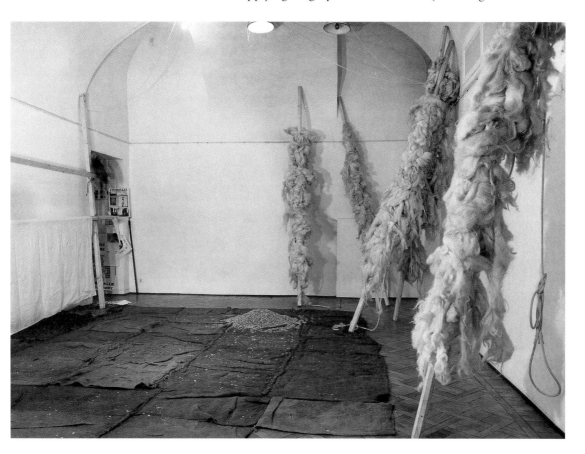

date of birth) and her withdrawal into an inner world of intimacy and reverie perhaps suggests a deliberate strategy rather than an enforced exclusion. In 1972 the critic Mirella Bandini asked her if she could record an interview for the arts magazine *NAC*. She had already taped hours of conversation with the other Arte Povera artists in Turin about their life and work. Marisa Merz declined the opportunity to talk about herself. Instead she conducted a brief interview with eleven-year-old Beatrice (Bea for short) in which mother and daughter discussed lunch. Since Bea could no longer have *panettone* as there wasn't any left, had her desire for it been real? Had it been as real as her desire for the potato

and mayonnaise that she could have? The domestic conversation turns philosophical until Bea rebels and calls a stop to proceedings. The episode is instructive in a number of ways. Firstly, an opportunity for self-publicity is rejected while the situation remains under the control of the artist. Secondly, Merz makes her daughter the protagonist instead of herself. Thirdly, an everyday domestic activity (making and eating a meal) is turned into an important matter for discussion, leaving the relationship between desire and

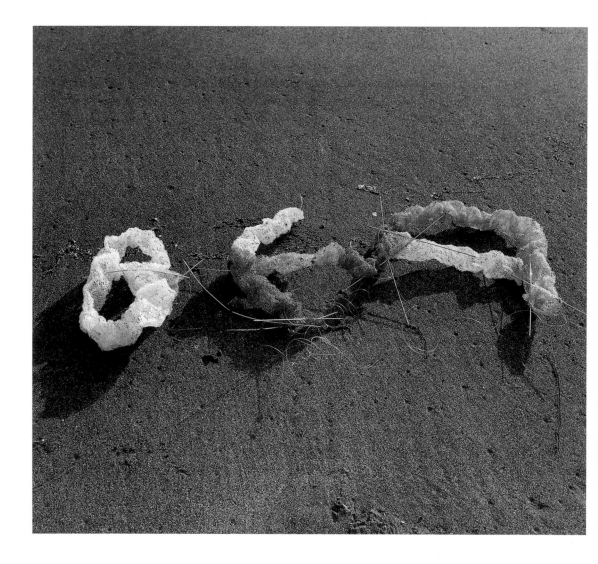

reality strangely unresolved.

In much of her work, Merz adopts a similar approach. *Small Shoes* 1968 (figs.23 and 24) and *Bea* 1968 (fig.22) are works knitted with nylon thread that were placed on the beach at Amalfi, away from the main exhibition area, where they were rendered even more delicate and fragile. The two versions of *Swing for Bea* 1968 were hung from the ceiling in the Merz home, and doubled up as

artwork and swing. The presence of the young girl is woven into the art. Merz recalls: 'Everything was on the same level, Bea and the things I was sewing. I was equally open to all these things' (Grenier, 1994, p.185). If Fabro and Paolini attempt to 'objectify' subjective sensations, in Marisa Merz the subjective is not measured but evoked. Her works in thread are elusive and enigmatic, and, like a spider's web, never complete. In Rudi Fuchs' words, 'the idea of shapeless form, of shapes continuously absorbing other shapes always intrigued her' (Fuchs in Grenier, p.253). The sense of intimacy and reverie that Merz summons up brings to mind a passage in Gaston Bachelard's *The Poetics of Space* 1958, about the 'retreats of solitary daydreaming': 'Here space is everything, for time ceases to quicken memory … Memories are motionless, and the more securely they are fixed in space, the sounder they are.'

At the Attico show of 1969 Mario Merz carried the rolled and bound woollen blankets (*Untitled. Blankets* 1967) made by Marisa on his shoulders. This act of holding up his partner's work was indicative of a relationship that was based on mutual support but separate artistic identities (Tommaso Trini noted that their names were separated by just two letters of the alphabet). Their work has never been shown in the same public space. Mario Merz, in contrast to Marisa, participated in all the group shows except for the first one, and his signature igloo was used for the front cover of *Arte Povera*. For Celant, he became a key protagonist when the critic developed a more anthropological idea of Arte Povera in which the role of the artist was linked to the shaman and nomad. A photograph of the time shows him as a dark brooding figure emerging from a misty landscape. He is holding a block of wax that he had placed in a tree to 'measure' the space between the branches.

Born in 1925, Mario Merz was the oldest member of the group. In the final year of the war, when the others were children, he was a partisan fighting the Nazis and the Fascists. When he joined the Sperone Gallery in 1966, Merz was throwing off his past as a painter associated with expressive, abstract Art Informel in order to make assemblages of everyday objects and projecting canvases that he pierced with tubes of neon, as in *Raincoat* 1967, *In the Street* 1967 and in *Umbrella* 1967 (fig.27). In 1968 he began to make installations, and created his first igloos. His *Giap's Igloo* (fig.28) was exhibited that year at the Deposito d'Arte Presente, a converted industrial premises in Turin made available for use

by artists (fig.8, p.20). This led, in turn, to his exploration of Fibonacci numbers – the numerical sequence devised by the thirteenth-century mathematician Leonardo Fibonacci to account for the spiral expansion thought to underlie the natural phenomenon of growth. In *Snail* 1970 Merz was filmed by Gerry Schum as he drew a spiral on a pane of glass with a snail placed at eye-level in the centre (fig.25) – his movement, the line and space that resulted from it and the shape of the snail's shell replicated one another in potentially limitless expansion. Each of these shifts in Merz's practice represented an outward movement. On the one hand, there was a greater physical occupation of the space as the neon Fibonacci numbers climbed the outside of buildings as well as the walls and stairwells of interiors (fig.26). On the other, there was a metaphorical reaching out that entailed the creation of an individual cosmology in which archetypes referred to a primordial state of being outside time.

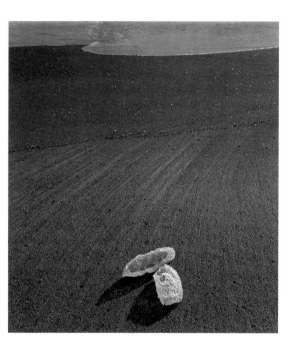

Thomas Crow interprets Merz's igloos, made in a variety of materials ranging from dried saplings to jagged panes of glass, as a 'Beuysian evocation of a nomadic, primitive substratum recoverable from a corrupting modernity' (Crow, 1996, p.147). Arte Povera, and particularly Merz, has often been seen as part of the wider 'romantically anarchistic longing' associated with the German artist Joseph Beuys and the 1968 student revolts. However, this assessment needs to be regarded with care. Most of the artists associated with Arte Povera were reacting against an expressive use of materials. They were also reacting against the romantic conception of the artist, which Beuys too rejected, yet paradoxically fostered with his shamanistic persona. Merz himself, along with the other Italian artists, had no connection with Beuys until the 1970s. His link to wider European developments was, rather, through his friendship with the members of the Situationist International. In the early 1960s the SI had met at Alba in the house of Pinot Gallizio, a pharmacist who started painting in his fifties and became a role model for many of the artists in Turin. Merz absorbed their critique of the Bauhaus ideals of modernity and the rationalism of industrial societies, especially regarding architecture and urban planning (for instance, Le Corbusier's idea of the house as a 'machine for living in' was totally alien to Merz). On an unconnected, yet seemingly parallel trajectory to Beuys, myth and primitive forms, instead of being dismissed as 'irrational', offered Merz elements for the construction of an alternative

24
Marisa Merz
Small Shoes 1968
Nylon thread
Dimensions unknown
Private Collection

25
Mario Merz
Snail 1970
Film still from Gerry Schum's video
Stedelijk Museum, Amsterdam

26
Mario Merz
Fibonacci's Progression 1971
Neon
Dimensions variable
Photograph of work installed at the Guggenheim Museum, New York 1971

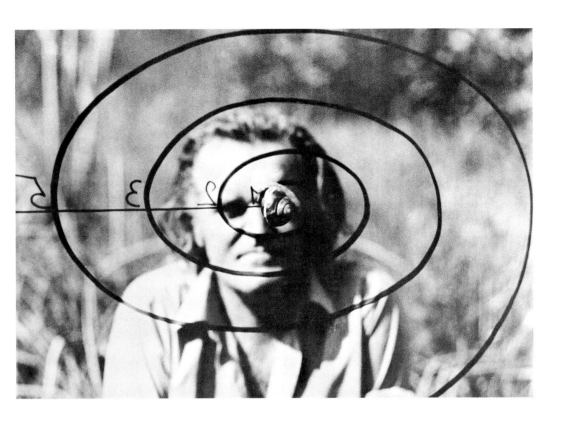

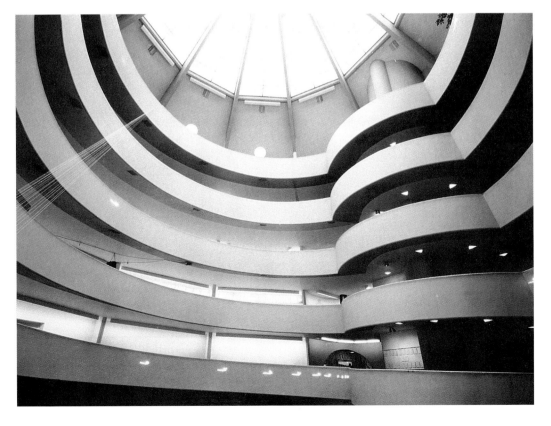

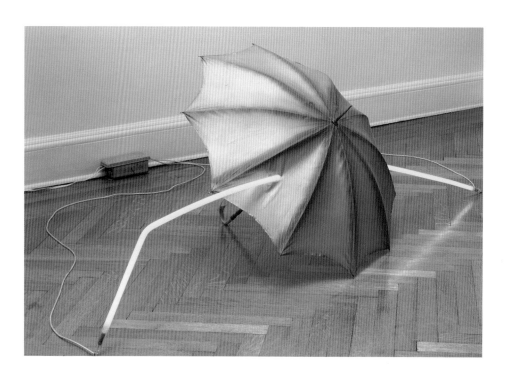

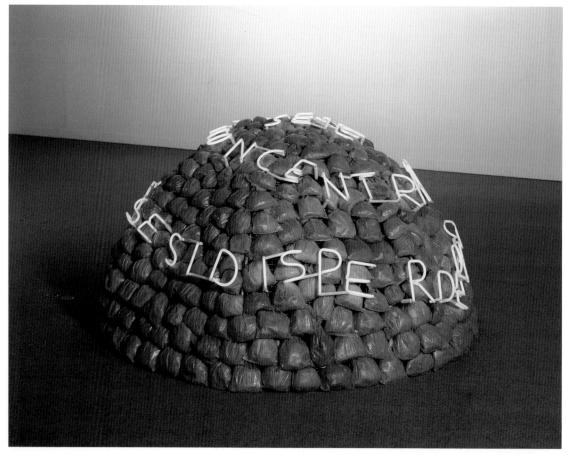

language and social practice. It gave him a new freedom in thinking about materials and the conventions governing how they were to be combined. Space assumed meanings freed of functionalism and repetition. Time ceased to be linear, evolutionary or even measurable.

Merz is often described in terms of his 'visionary and artistic power', to cite Harald Szeemann, who included him in Documenta V in 1972 in the section entitled 'Individual Mythologies'. Yet his work is more contemporary than this implies, while retaining an ambiguity that deflects simplistic political analysis. *Giap's Igloo — If the enemy masses his forces he loses ground, if he scatters he loses strength* 1968 (fig.28) is a good example. The sculpture has no base, just as the Eskimo habitation has no foundation. The dome of wire mesh is clad with bags of plastic filled with earth, around which Merz has formed in neon the words of the North Vietnamese general Vo Nguyen Giap, theorist of guerrilla war. 'A viewer', writes Corinna Criticos, 'has to walk around the work several times, slowly, to decipher the phrase. It unwinds in a spiral form, a shape that recalls the double helix and other primary biological forms. The viewer performs two acts simultaneously — walking and reading — thus following the contour of the form both physically and mentally' (Criticos, p.75). While the Vietnam War (and even Celant's invocation: 'we are in the middle of a guerrilla war') might come immediately to mind, Merz insisted on the biological and philosophical implications:

I was fascinated by the sensual structure. The idea is round. Look at how the idea of General Giap neutralises itself. If you follow the phrase through, you come back to the beginning; it circles around and then comes to a rest. There is no clarity, no logic, no progression to it. It is a contained dynamic force … It has no support, it is concave as well as convex, just like the military tactic. (Ibid., p.77)

For Merz, the political was best approached through metaphor and an engagement that was detached but never indifferent.

IMPEDED MOBILITY: EMILIO PRINI

Of all the artists associated with Arte Povera, Emilio Prini is the most elusive, intransigent and has the fewest works to his name. He is also the least written about and perhaps the least understood; Celant was the only critic seriously to promote and comment on his work. Prini was included in all the Arte Povera shows but has scarcely exhibited as an artist outside of Arte Povera and his work has barely been seen subsequently. This absence can partly be explained by the fact that Prini has produced very few of the 'art objects' required by the market and public museums. But his marginality also arises from the strategy he has consistently adopted. Richard Flood and Frances Morris comment that 'from early on, Prini was as concerned with exploring hypothetical projects as he was with realising finished work, and the erasing of work or the covering of its traces was often more important than its production' (Flood and Morris, 2001. p.17). Prini even forbade the translation of his writings for the book *Arte Povera* into English or German. A recent survey of Arte Povera that contains an anthology of key historical texts includes only new work by Prini (Christov-Bakargiev, 1999). For Friedemann Malsch, 'Prini is convinced that life exists

only in its concrete enactment and the expression of this conviction is a constant in his oeuvre. He has remained uncompromisingly faithful to his own principles, going as far as to prohibit the publication of his works in catalogues and retrospectives in order to preserve their authenticity and singularity' (Malsch, p.184).

In 1968 Celant noted: 'Prini moves in a void. The tracks he leaves are one with the movements of his body … By signing the empty rooms of a gallery he "takes possession" of the container' (Celant in Christov-Bakargiev, p.273). *Perimeter of Air* 1967, shown in the first Arte Povera exhibition, uses five neon lights placed in the four corners and centre of the room, which are illuminated in a relay system accompanied by sound to make viewers aware of the space and their relationship to its edges. While this shares Luciano Fabro's preoccupation with spatial perception other works by Prini deliberately sets out to frustrate and impede viewers. For the series entitled *Hypotheses of Action*, he uses lead sheets scattered on the floor as supports for texts in such a way that viewers have to move from one to another to complete sentences and phrases. The act of reading becomes a struggle in the physical sense of bending and moving backwards and forwards as well as in the mental sense of trying to connect the fragments into meaningful wholes. The heaviness of the lead (measured in relation to the artist's body) contrasts with the lightness of the 'hypothetical actions' listed in the text: 'I went on a trip with Renato … I read *Alice in Wonderland*. I ate an ice cream. I jumped from a height. I burnt my notes.' Prini's installations are designed to make the viewer work, to create disturbance and to interrupt mobility.

3

MATERIALS, ENERGY AND PROCESS

In an article in *Domus* in January 1969, Trini described the approach to materials among artists in Italy at the time: 'If they introduce materials previously unused in art – materials such as earth, asbestos, graphite, ice, birds, wax, tar, wire mesh and chemicals – it is for reasons of convenience, first of all, and then to make their relationship with reality as free and as fresh as possible.' Later in the same article he readdressed this issue in a subsection entitled 'An Alphabet for Matter':

If Mario and Marisa Merz, Prini, Zorio, Boetti or Anselmo had at their disposal the very latest materials from Dow Chemicals or programmes and computers from IBM, they would not fail to use them. But exactly the same applies to craft or household materials to hand. To the extent, that is to say, that they constitute elements of a process calling for total involvement and leading to liberatory experiences and the affirmation of original needs. Just as this art rejects fashionableness, so it fears technological richness: there is no need for it even to be declared anti-technological. Everything is at its disposal; everything flows from the necessity for the means. The emphatically anthropological direction taken by the research of these artists means that they treat materials, and therefore objects, as vehicles for bricolage in both a mental and behavioural sense.

Trini's analysis is particularly significant because it represents an alternative to Celant's. Here he is arguing against Celant's markedly political interpretation of the art and refuting the idea that it was 'anti-technological' per se. For Trini, the artists were 'un-ideological' and 'apolitical'. They were not opting for some materials rather than others for motives outside and beyond their art. Linguistic experimentation not political agitation underlay their artistic

strategies. Yet there is an ambiguity at the core of Trini's position. On the one hand, the attitude to technology ascribed to the new art is described as entirely open and experimental. On the other, there is the statement about 'fear' of 'technological richness'. In part, this contradiction stems from the need to distinguish between an ideological opposition to advanced technology per se and a political opposition to its use for oppressive purposes. However, the idea of *bricolage*, which is derived from Claude Levi Strauss's anthropological studies, presupposes 'poor technologies' and a maximum of human ingenuity rather than the technology and specialisation of American multinationals. Even if in theory the artists had no bias against advanced technologies, in practice they tended to use materials that were easy to manipulate or process either directly themselves or with the aid of people with the appropriate skill or expertise.

We have already seen the different approaches to materials adopted by the Arte Povera artists. Paolini adopted for some time a strategy of limiting himself to the use of materials typical of the traditional painter; by contrast, Mario Merz's work operated according to a logic of expansion and proliferation that involved incorporating a huge variety of material in his work, as shown by his igloos. The risk of focusing too much on 'poor materials' in any discussion of Arte Povera is that it can lead to an idea that it was nostalgic and regressive. The use made of photography by Kounellis, Paolini and Pistoletto reveals a sophisticated understanding of the possibilities of the medium that contradicts such a notion. As Flood and Morris write, Arte Povera showed:

a remarkable appetite for new materials and a restless desire to explore new processes. Art could be made from anything: living things, products of the earth, and industrially produced materials, as well as immaterial substances such as moisture, sound and energy. Art could be made in any way. It could be painted, handcrafted, industrially produced, gestured, spoken, written, acted, filmed, dreamed. It might exist as an object for time immemorial or as a momentary time-based action. (Flood and Morris, 2001, p.15)

However, there are three artists who are particularly associated with the exploration of the properties of materials, and as such can be treated as a sub-group within Arte Povera: Gilberto Zorio, Giovanni Anselmo and Giuseppe Penone. For them, materials were of interest in so far as they embodied or acted as conductors for energy. According to the writer on theatre and performance art Nick Kaye, their early work 'directly challenged the conventional opposition between "physical things" and the "abstract order" of the art world, opening sculpture to forces and events precipitated by the presence of materials, to "natural" and organic processes identified with particular locations as well as exchanges between material processes, the environment and the body' (Kaye, p.142). They not only subverted the idea of the discrete art object but created 'virtual spaces' that impacted on the real spaces in which they were located, furthering the process of metamorphosis. This section concentrates on the particular contribution of Zorio, Anselmo and Penone, whilst contrasting it with that of Pier Paolo Calzolari, whose use of materials such as ice bore superficial similarities to their work but was quite differently motivated.

THE UNSTABLE OBJECT: GILBERTO ZORIO

When Gilberto Zorio was included in the Arte Povera exhibition of February 1968, he was the youngest artist at only twenty-three years old. And yet he seemed to know exactly where he was going. In 1966 he had already attained, as he told Mirella Bandini, a 'fusion of idea and form' in his work (Bandini, 1972, in Flood and Morris, 2001, p.324). His *Tent* 1967 (fig.29) developed in the context of the landmark *Arte Abitabile* (Habitable Art) exhibition in which the

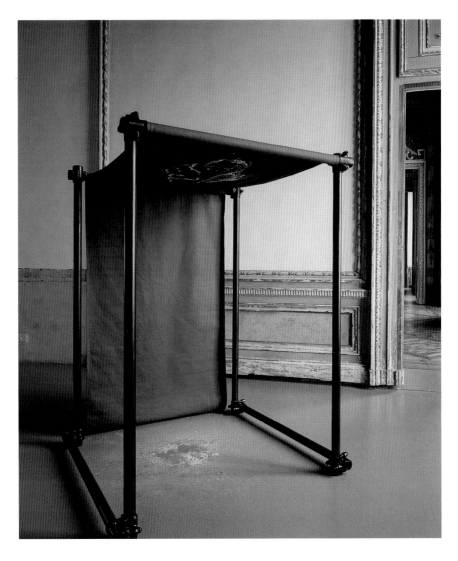

29
Gilberto Zorio

Tent 1967

Tubes, clamps, green cotton canvas, seawater
170 × 131 × 125
(66⅞ × 51½ × 49⅝)
Collection Margherita Stein; on permanent loan to Castello di Rivoli Museo d'Arte Contemporanea, Rivoli-Turin

Sperone gallery was transformed into a strange domestic environment. Zorio had salt water poured onto the flat 'roof' of a blue canvas cube stretched over scaffolding tubes; the water slowly evaporated, leaving behind crystalline deposits. For *Seat* 1967 Zorio suspended a weight, above the place where a person might sit, in the middle of a pile of foam-rubber off-cuts. In the first work, the artist added a natural element to a man-made structure, and allowed

the process of evaporation to 'paint a picture'. In the second work, he created a
situation of imminent danger. These works have aspects in common with those
of Piero Gilardi (for whom Zorio worked as an assistant). *Seat*, for instance,
uses synthetic materials, like Gilardi's 'nature carpets' (fig.7, p.19) made from
polyurethane, which simulated natural forms such as leaves and fruit. Both
works create an environment as in the *Arte Abitabile* show. However, Zorio's work
clearly departs from Gilardi's adoption of mimesis and the stable object.

As Celant wrote: 'Zorio is interested in the precariousness of events, the
"relativity of things" and the potential energy of the world.' Materials were not
of interest in themselves but chosen for the 'potential energy' they contained.

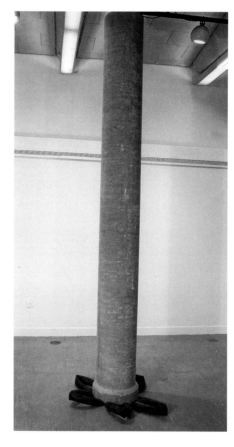

When Zorio spoke with Gilardi in
January 1968 of the experiences that
had helped shape his work, he
stated: 'Tactile and visual
experiences are essential to me: the
steel cables of a crane lifting a heavy
weight; the contact of my hands and
face with the white, soft, swollen
and cold snow; I love wet
phosphorous, which catches fire on
contact with the air; I love the slow
power of tar' (Lumley, 2001, p.53).
This evocation of the physical
sensations of these unstable
materials – snow, tar, phosphorous
– is unusually compelling. Their
properties mutate at varying speeds
and both the slowness of the tar and
the speed of the phosphorous
enthrall the artist. No distinction is
made between natural and industrial
materials (though his words make it
easier to imagine a construction site
than a rural landscape and, as it
happens, Zorio's father ran a
building company in Turin and
helped his son with materials).

Looking back on the change of direction taken by Arte Povera work between
1967 and 1968, Zorio remembers that 'we stopped talking about language,
colour and form; we talked instead about reactions, tensions, existential
situations – all in parallel with life' (Bandini, 1972 in Flood and Morris, p.325).
Materials were significant in so far as they enabled him to explore these
dynamics. In this light, it is interesting to look more closely at his use of two
distinct types of material: rubber and chemicals.

In *Column* 1967 and *Stain III* 1968 (figs.30 and 31), rubber is used in very
different ways, illustrating the freedom with which Zorio utilised materials.
Column pursues the theme of habitation present in *Tent* and *Chair*, but the iconic

architectural form is turned on its head. Instead of supporting a structure, the nine-foot-high cylinder bears down on the semi-inflated rubber inner tube with its eighty kilos of fibre cement. Instead of providing stability, it precariously balances on the rubber without even touching the ground. For its part, the rubber, a vegetable material, has lost its natural elasticity under the weight. The air trapped in the black lung cannot escape. The viewer too is caught up in the tension. In *Stain*, by contrast, the sculpture is hoisted on high, occupying the entire space and opening up an aerial horizon. The work was made by pouring liquid rubber on the ground in concentric circles on top of strands of rope that were then raised up so that they radiated from the congealed material holding them suspended. Whereas the

rubber in *Column* takes the form of a found, industrially produced object, here Zorio drips the liquid rubber in a manner reminiscent of Jackson Pollock, so that gesture, gravity and viscosity determine the shape of a work whose very title suggests an involuntary action. Furthermore, the rubber loses its passive position on the floor to become an active definer of the space in which the viewer moves.

In *Two Lead Basins* 1968, Zorio develops his interest in process, using metal and acids in a floor-piece that is propped against the wall. Two roughly fashioned lead containers hold different kinds of acid – sulfuric on one side, hydrochloric on the other – linked by a bar made of copper. Zorio describes what happens:

> When sulfuric acid comes into contact with the copper, it produces copper sulfate, salts of the most intense blue; the hydrochloric acid produces green salts …
> The crystals of copper sulfate climb the bar in a pyramidal pattern; the others ascend vertically. When the two components meet at the top, the work will be completed. It continues to live all the while. (Ibid., p.326)

The colour, Zorio insists, is the result of a chemical reaction independent of the artist. In *Pink-Blue-Pink* 1967, it is the presence of spectators that provokes changes in colour as cobalt chloride mixed with fibre cement reacts to changes of temperature and humidity. The prone mute object is endowed with a life of its own and responds to heat and air in a manner analogous to the human body. Indeed, in the German Conceptual artist Hans Haacke's words (whose work

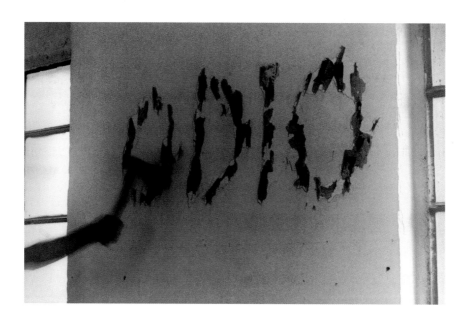

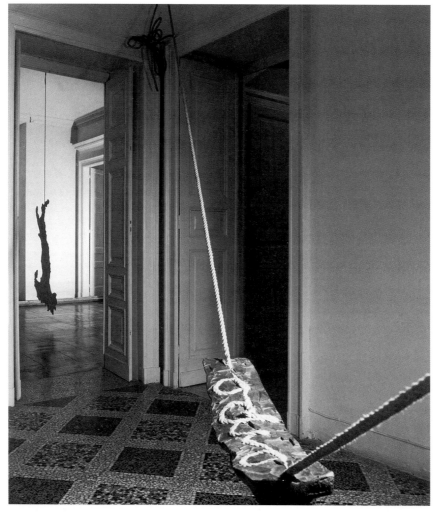

32
Gilberto Zorio

Odio (Hate) 1969

Hatchet cuts into
gallery wall

33
Gilberto Zorio

Odio (Hate) 1969

Lead, rope
Lead: 10 × 75 × 17
(3⅞ × 29½ × 6⅝)
Overall dimensions
variable
Private Collection

was included in the book *Arte Povera*): 'a "sculpture" that physically reacts to its environment and/or affects its surroundings is no longer to be regarded as an object. The range of outside factors influencing it, as well as its own radius of action, reach beyond the space it materially occupies.' Instead, it 'merges with the environment in a relationship that is better understood as a "system" of interdependent processes' (Haacke, in Celant, 1969, p.179).

However unlike Haacke, who was preoccupied with the 'objective' analysis of *systems* and the demystification of art, Zorio was concerned with *events* and with the mysteries of existence that art can reveal. He increasingly explored subjectivity – his own and that of spectators – in works that sometimes used, or made reference to, the body. Particularly significant in this respect is the *Odio* (Hate) series. The Italian word *odio* can mean 'I hate' as well as 'hatred': as a verb in the first-person singular it enunciates the act of hating; as an abstract noun it designates a state or condition. The distinction is important for understanding Zorio's work – work that holds in a state of tension both the active expression of feelings, and the stepping back from and analysis of those feelings. In one version (*Odio* 1969), Zorio hacked the words with an axe into the gallery wall. A photograph by Paolo Mussat Sartor captures the blur of the movement (fig.32): the action and the finished word equally constitute the work. The blows that cut away the plaster to reach the solid masonry behind and the jagged outline of the letters 'ODIO' express a destructive release of energy. Once completed, however, the word can be read and contemplated with detachment. In another version of the same year, Zorio hammered a rope into an industrial lead ingot to form the word (this time using cursive lower-case letters) (fig.33). The ends of the rope were then fixed to the walls to make a structure resembling a swing. Here the action is embedded as a memory in a metal known for its weight as well as its malleability (it takes two people to carry the ingot). In a third version of *Odio* produced in 1971, Zorio made a ring of Plexiglas to fit the diameter of his head with the word 'ODIO' inscribed in the inside in raised mirror writing. When worn, the word imprinted itself on Zorio's forehead. It left an impression that, though 'remembered' by the photographic print, was quickly 'forgotten' by the skin. The same could not be assumed, however, of the viewer, who could read the message as if it were directed towards him or her. The implied aggression – I HATE (YOU) – is nothing if not direct. The simplicity, force and precision of these works is remarkable. As Zorio put it: 'the language has to be one with the idea: never add, where possible subtract' (Bandini in Flood and Morris, p.326).

SITUATIONS OF ENERGY: GIOVANNI ANSELMO

Like Zorio, Giovanni Anselmo lived and worked in Turin. His day job from the early 1960s to 1972 was as a graphic designer for the drink manufacturer Martini and Rossi. He was a self-taught artist and produced work in his spare time. In 1966 he showed Sperone Polaroids of what he had made. The next year and again in 1969 he had solo shows in the Sperone Gallery. He participated in all the Arte Povera group shows, except for the first one, and exhibited in New York at Leo Castelli's gallery, alongside Hesse, Nauman and Sonnier. It is a telling fact about Anselmo's early career and about Arte Povera more generally

that, despite the international success, most of the artists struggled to make a living and to find buyers for their work. Yet their formative work perhaps benefited from this marginality. Anselmo, for example, pursued his experiments without compromise, driven by his ideas rather than by a desire for fame and fortune.

Anselmo's first work (though, strictly speaking, just a friend's snapshot) appears at the beginning of all catalogues of his work from the 1970s, and is presented as the moment of epiphany when his real life as an artist began. The photograph shows Anselmo standing on a slope of the volcanic island of Stromboli (fig.34). Jean-Christophe Ammann recounts the episode as experienced by the artist:

On 16 August 1965, he witnessed the sunrise on the top of Stromboli. The position of the sun, barely above the horizon, caused his body, as it were, to become shadowless: the shadow was invisibly 'projected into the air'. This unsensational fact was to have for him the significance of a revelation: 'My own person, through the invisible shadow, came into contact with the light, the infinite.'
(Ammann, 1979, in Christov-Bakargiev, 1999, p.234)

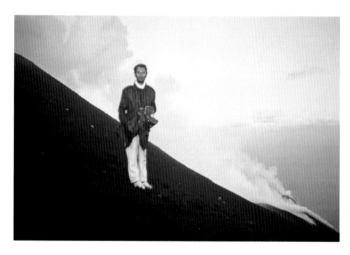

A number of elements combined to make the 'event' significant. Firstly, there was Stromboli itself, a meeting-point of the elements (fire, earth, air and water), where volcanic activity exposed inherent instability, precarious balance and the dependence of humans on natural forces. Anselmo subsequently returned every year to this stark island with its black lava and lack of vegetation. But more important than the material surroundings was the sudden awareness of being a part of, rather than separate from, the natural forces of the world – what could not be seen, whether it was gravity or magnetic fields, determined what could be seen. Anselmo's art set out to make this invisible visible.

In 1966 Anselmo made a group of objects that instantly fascinated Zorio and other artists represented by the Sperone gallery. He screwed thin metal rods into blocks of wood, making them the maximum length that could sustain an upright position (fig.35). Their instability became evident when the slightest movement of air caused by a viewer made them tremble. In Anselmo's words, 'The traditional object is reduced to a minimum, or ... exists only as a function of tension, of energy.' The simplest of materials are put together to make objects that neither look like works of art nor solicit a response based on knowledge of art. On the contrary, the viewer, when standing, shares in the same situation of verticality as the works themselves.

This analogy between the artwork and the human body is a theme that also

runs through Zorio's early oeuvre (see *Pink-Blue-Pink*, for example). Anselmo explores it in works such as *Untitled. Drinking Structure* 1968, *Untitled. Eating Structure* 1968 (fig.36), *Torsion* 1968 (fig.37), and *Breath* 1969, whose titles suggest that he sees these works as living organisms. In *Arte Povera* Anselmo states:

I, the world, things, life – we are all situations of energy. The point is not to fix the situations, but to keep them open and alive – like life processes … Because … to work with energy requires total freedom in choosing and using materials. The words style, form, antiform become meaningless in this context.

For *Drinking Structure*, Anselmo allowed cotton to 'drink' the water in the steel container. For *Eating Structure*, a lettuce is wedged between two granite blocks and the structure must be 'fed' continually with fresh lettuce leaves if the smaller top block is not to fall to the ground. (Anselmo also considered using meat, but never did so in practice.) For *Breath*, a piece of sea sponge is inserted between two iron bars; when the temperature rises, the iron expands and squeezes air out of the sponge; when the temperature drops, the iron contracts and the sponge can 'breathe' in air again. In each work the materials constitute 'situations of energy'. This is particularly evident in *Torsion*, where Anselmo twists leather fixed in a block of cement and holds it in place with the wooden pole jammed against the wall. His action is transformed into the reaction of the leather, energy locked in a state of extreme tension.

34
Giovanni Anselmo
My shadow turned towards infinity from the top of Stromboli at dawn on 16 August 1965 1965
35mm colour slide
Courtesy of the artist

35
Giovanni Anselmo
Untitled 1966
Iron rod, wood, gravity
265 × 15 × 15
(104¼ × 5⅞ × 5⅞)
Private Collection, Turin

Zorio's work makes frequent reference to social processes and tensions, and he openly addresses the parallels between his work and life in interviews. By contrast, Anselmo's work refers to natural processes without any suggestion that they relate to social situations. As Ammann has written, Anselmo moves from the abstract to the particular in order to make the abstract graspable. Time in his work is not historical but biological and geological. *Direction* 1967 and *Untitled* 1969 are good examples.

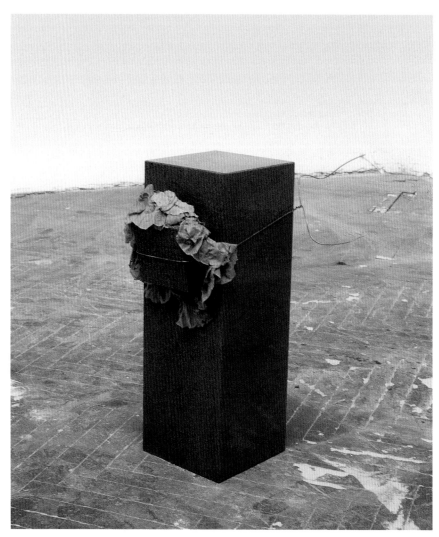

36
Giovanni Anselmo

Untitled. Eating Structure 1968

Granite, copper wire, lettuce
70 × 23 × 37
(27½ × 9½ × 14½)
Collection Musée National d'Art Moderne, Centre Georges Pompidou, Paris

Direction exists in various versions, including an action carried out at Amalfi in which Anselmo, in Gilardi's words, 'laid a wet sheet on the floor and then with a cylinder containing a compass split it crosswise in a northerly direction: the inertness of the wet cloth turned the gesture into a crystallised image'. Another version consists of a roughly triangular fragment of granite into which a compass has been inserted. The heavy rock lies motionless on the floor; the needle of the compass, however, hovers as it responds to the invisible power

of magnetic forces. The rock, which is aligned to the north, draws the eye of the viewer away from itself and in the direction indicated. The needle, too, points beyond the real space of the gallery to a virtual space that can only be imagined.

Untitled 1968 (fig.38) consists of a large fragment of rock hung as high as possible on the wall with steel cables. Gravity tightens the slipknots with which the rock is secured, but according to the law of physics, Anselmo points out,

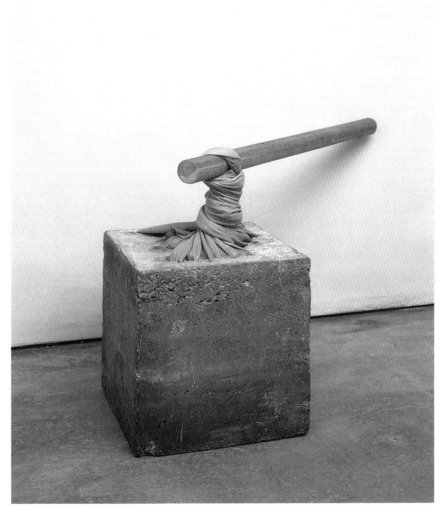

37
Giovanni Anselmo

Piccola torsione
(Small Torsion) 1968

Concrete, leather, wood
Concrete block:
37.5 × 37.5 × 37.5)
(14¾ × 14¾ × 14¾)
Length of piece of
wood: 100 (39⅜)
Goetz Collection,
Munich

the gravitational pull lessens the further the rock is from the Earth. 'It is possible to imagine', notes Anselmo, 'that high up in the universe, somewhere between the Earth and the Sun, it would become entirely weightless and could perfectly well fly' (Meinhardt, p.54). The stone used by Anselmo was an Alpine granite commonly quarried as a building material. It is valued above all for its hardness, density and weight, not for the kind of aesthetic associations attached to marble, for example. Granite became a signature material for Anselmo.

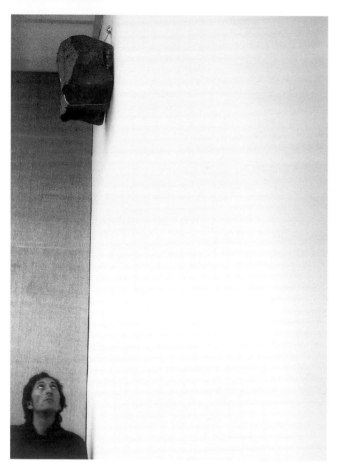

38
Giovanni Anselmo

Untitled 1968

Stone, suspended from
as high as possible on
a wall by a steel cable
Dimensions variable
Collection of the artist

39
Giuseppe Penone

Read, Write, Remember
1969

Iron wedge, tree

40
Giuseppe Penone

Tree of Five Meters
1969–70

Spruce wood
494 × 19.5 × 10
(194½ × 7⅝ × 4)
Collection Margherita
Stein; on permanent
loan to Castello di
Rivoli Museo d'Arte
Contemporanea,
Rivoli-Turin

However, the paradox in works like these is that because we are drawn to look beyond the object to the idea, the material that stands for Earth and materiality is rendered immaterial. The object is only of significance in making the idea visible.

PROCESS AND REVERSAL: GIUSEPPE PENONE

In 1966 Giuseppe Penone attended the Academy of Fine Art in Turin, where his future friend Zorio was also studying sculpture, but within a year he abandoned studies that he had come to feel were useful only for avoiding military service. He returned to the mountain village in Piedmont where his father had a small farm and continued to make art in a disused warehouse attached to a sawmill. His distaste for academic art education was not untypical of the Arte Povera artists, the majority of whom had no Fine Art training. More often there was a family background in art or a related craft (for example, Gilardi's father restored church frescoes). Penone's grandfather was a sculptor. The decision to

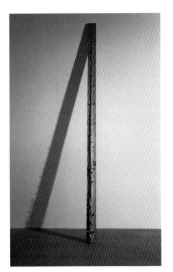

leave the Academy was in keeping with the spirit of the times, in which traditions and institutions were seen as obstacles to understanding the world. Going back to Garessio was, for Penone, a way of getting in touch with reality. However, in Turin he had made important contacts. He was to show his first work at the Deposito d'Arte Presente in 1968 and at the Sperone gallery. Here it came to the attention of Celant, who promptly included examples in the book *Arte Povera*. Then aged twenty-one, Penone was the last artist invited by Celant to participate in the group shows. While he worked initially in the depth of the provinces, Penone continually travelled to Turin and was quickly part of a wider international art network.

The outdoor work *Stone Rope Sun* 1968 shows the affinity between Penone, Zorio and Anselmo. Rope, tied to a tree at one end and to a square piece of metal at the other, changes length depending on whether the weather is wet or dry. The metal object is lowered and raised accordingly. The energy intrinsic to hemp is thus 'externalised' through a simple structure and its exposure to natural forces. When Penone returned to the country, it was trees that became his materials; firstly, living trees in Garessio; then, trees that had been rendered into beams.

The series of actions using living trees was made in 1968. In one work he gripped a slender tree-trunk then made a bronze replica of his hand performing this gesture. He placed this sculpture on the same part of the trunk and left it there so that it would prevent any further growth at that point. In another work he embraced a tree with his whole body then bound wire around the tree at the points where his body had made contact with it. Photographs with brief hand-written descriptions of these actions were published in *Arte Povera*. With *Read, Write, Remember* 1969 (fig.39), Penone is photographed hammering a metal wedge (inscribed with the numbers 1–9 in relief mirror writing) into a tree trunk. The tree would, in turn, reproduce the shape of the numbers with its sap (write), then absorb (read) and internalise (remember) them. As with Zorio's *Odio* (figs.32 and 33, p.48), the work exists as an action,

as the memory of an action (again photographed by their friend Mussat Sartor) and as physical reality. But Penone's work continued to grow and change, part of a continuous natural process, and not reducible to a single instant in time. Over the years the trees would absorb the artist's interventions as the soft tissues hardened and added rings of growth. Any idea of the finished art object or authorship was thereby rendered problematic. Penone, moreover, insisted that the trees be seen as trees; that is, as natural materials and energy, not signs or symbols belonging to culture. In this respect, his approach was utterly different from that of Mario Merz, who, according to Penone, 'takes conventions and models as his point of reference' and 'clings to the conventions of painting' by taking a 'structure that already exists and filling it with materials' (Schreier, p.157). It was closer to that of Anselmo, whose work was 'an intervention in the order of things and came from somewhere beyond painting and sculpture' (ibid., p.157).

Had Penone's work taken a different direction, Arte Povera might have created the basis for the development of Land art within Italy. However, Italy remained largely untouched by the kind of work that was being carried out by artists from Northern Europe, such as Richard Long or Jan Dibbets, despite their connections with Arte Povera (Long took part in the Amalfi events and became friends with Penone). Arte Povera brought natural materials into the museum and turned them into art. In the Italian tradition, it was an urban phenomenon in almost every way. Penone did not break that mould. Nor did he seek to, beginning to work with wood, rather than with living trees, and to think in terms of exhibitions in gallery spaces such as those offered by Sperone. However, he pursued a logic that was integral to his previous work. He now searched for the natural process that had been terminally interrupted when a tree was felled. Seeing a tree *within* a large 'industrial' beam propped against the wall, Penone identified the knots (formerly branches) and chiselled the wood until it re-emerged from the plank; 'it's almost a tautology' says the artist, 'a piece of wood that becomes a tree' (ibid., p.157) (fig.40).

This 'discovery' of the tree in this second phase of Penone's work constituted a decisive moment. In part, it can be seen as his recovery of an Alpine tradition of sculpting in wood – the artist being true to his cultural roots. However, there is a danger of equating the use of a 'traditional' material with nostalgia. Penone was pursuing an analytical inquiry that was concerned with questions of the body and identity, and how to visualise processes such as growth and aging. The tree and the human body (the body of the artist) were understood as a continuum. The bark was the equivalent of skin, and the human body, over time, showed signs of its past growth just as the tree did. The problem, the artist told the author, was to 'find the form within the material, not use the material to find the form'. The method adopted by Penone was to 'reverse' a process that he visualised using the analogy of cinema: 'In a way, I see what I am doing as a movie sequence that's filmed in reverse, then fast forwarded through the projector.' Photographs then served as a support that explained 'the three basic phases of the work: the original beam, the moment at which the incomplete tree become visible, and the tree in its original/final form' (Christov-Bakargiev, p.266) (fig.41).

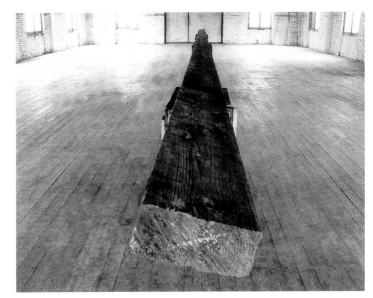

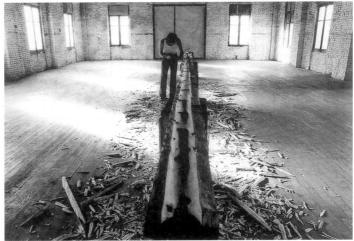

41
Giuseppe Penone

Tree 1969–70

Wood
348.5 × 19 × 9
(137⅛ × 7½ × 3⅝)
Photographed by Paolo
Mussat Sartor

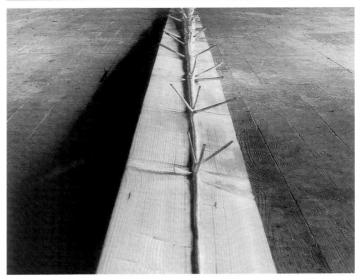

In part, photography was simply documentation, but more significant for Penone was the role it played in helping him to visualise and conceptualise exchanges between different materials, and between the body and everything with which it came into contact. In a work entitled *Unroll Your Skin* 1970–1, Penone used human skin and photographic emulsion as equivalents, transposing into images the marks left by grease prints and other traces on glass. He also re-visualised objects in terms of the imprint human bodies made on their surfaces. In a continuous exchange, skin bore traces of objects and the environment, and, likewise, objects bore traces of skin. 'Grease marks', wrote Penone, 'the organic layer on the seats of trains, the handles of hoes, banisters, tram supports, window panes, cuffs, arms of chairs, tables, pillow-cases, and on books and on walls – all reveal a contact that has taken place and point to places touched and the parts of the body used' (Penone, 1997, p.62).

Penone's first work involved the physical contact between his body and living trees. He went on to explore the imprint of his body in urban situations. Nature, for Penone, was a continuum of materials and energies of which humans were a part, not a backdrop landscape or separate sphere of life.

THE POETIC: PIER PAOLO CALZOLARI

When asked to provide a photograph for the biographical notes in the catalogue for the 1969 exhibition *When Attitudes Become Form*, Pier Paolo Calzolari sent a picture of himself as a little boy of four or five. It is an image that could have come from a family album, its private and intimate nature at odds with the conventions of exhibition catalogues. The use of the photograph was, however, totally in keeping with Calzolari's ideas about art and the artist, and chimed with Harald Szeemann's hippie-style call to 'live in your head', the subtitle of the show. Calzolari exhibited his *Horoscope as project for my life* 1968, a work made of a copper tube covered with frost, forming the appearance of a star on its wandering course across a surface of polished lead. The poetic title evokes astral influences while the white frost conjures up an image of remoteness and enigma. At the same time, there is a hint of mischief in the title.

Horoscope was also shown at the *Op Losse Schroeven* show in 1969, taking up a large portion of a wall as part of an installation entitled *La casa ideale* (The Ideal Home) 1968 (fig.42). On the floor were other works in which frost coated metal structures, such as *Impazza angelo artista* (Madden Angel Artist) 1968. Three columns of pink ice stood in an area adjacent to that occupied by an albino boxer dog. Calzolari's work was designed, in Catherine David's words, to 'contaminate the real with the imaginary', and 'to create new sensations and emotional states' in which all the senses were activated (David, p.14). There was also a strong element of drama in this time-based work: as the ice melted, the dog, maybe hypersensitive to the reflections in the melted ice, would begin to bark, evoking the madness and delirium associated in the Romantic imagination with the creative process.

Although the poetic register was regarded with some suspicion by those artists for whom it was redolent of the literary allusions that Arte Povera artists claimed to eliminate from their work, Calzolari was quickly included in the group following the Arte Povera show of February 1968, in which his work was

exhibited. His work, he recalls, was in sympathy with an attitude that 'aspired to broaden as much as possible the field of the perceptible and the formal and artistic media that at the time were for the most part limited to the impression of the paintbrush and the tactility of sculpture' (Zacharapoulos, p.80). Calzolari freely alluded to 'the poetic', especially in his titles and accompanying texts, but his work was about effects and responses that involved all the senses and used whatever means served this purpose. His contribution to the exhibition *Teatro delle mostre* (Theatre of Exhibitions) held in Rome in May 1968 was typical of his approach. He placed a square block of red-coloured ice in a container and let it slowly melt into another container below it, provoking a billow of violet steam that filled the entire space. As Maurizio Calvesi wrote at the time, the artists were moving beyond a more phenomenological exploration of perception to investigate consciousness and experience. In doing so,

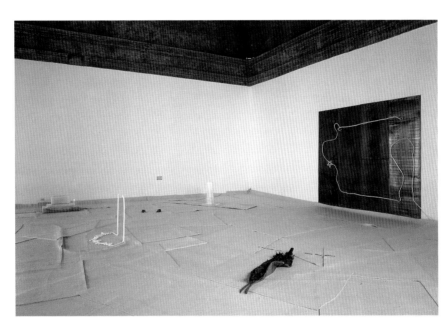

42
Pier Paolo Calzolari

La Casa Ideale
(The Ideal House)
1968–94

Installation at Castello di Rivoli Museo d'Arte Contemporanea, Rivoli-Turin 1994

Calzolari was not alone in appealing to the child in himself and in the spectator. A few months later, sitting on the beach at Amalfi, Alighiero Boetti told a television interviewer:

It isn't the materials that are important, it is the attitude … I don't want to waste time finding the art object. These things are suggestions – a mental method to help you see reality and life when we are all completely conditioned and alienated so that we can't see anything any more. For example, at this show there was a little box full of perfume and it was only the children that put their noses in it, the adults never did.

For Calzolari, too, art was a way of reawakening sensibilities blunted by a society fearful of freedom.

4

LANGUAGE, IDENTITY, PLAY

The major issue in art now', wrote Robert Smithson in 1968, 'is what are the boundaries?' Two years later, Mel Bochner observed: 'A fundamental assumption in much recent past art was that things have stable properties, i.e., boundaries ... Boundaries, however, are only the fabrication of our desire to detect them' (Lippard, p.166). Smithson and Bochner were part of a new generation of artists who were asking what exactly art was, and what constitutes an artist. The theoretical contributions to *Artforum* of these young artists, not least Sol LeWitt's 'Paragraphs on Conceptual Art' of June 1967, had been circulating in translation in Italy, feeding into the debates stimulated by Arte Povera. In 1969, with the major survey exhibitions in Berne and Amsterdam, and in 1970 with the exhibition *Conceptual Art Arte Povera Land Art* in Turin, it was possible for the Italian artists to see at first hand the work of Smithson, Bochner and LeWitt, not to mention Eva Hesse, Robert Morris, Joseph Kosuth and Bruce Nauman. The huge interest in Conceptual art produced in America in particular sprang from its affinities with the Italians' own practices. It was precisely because there was already a tradition of Conceptual art in Italy (before the term gained currency) that the reception was so positive. In fact, Celant included Manzoni's work in the Turin show as if to underline this point.

In a review of *Conceptual Art Arte Povera Land Art* published a year later, Trini wrote:

Revolutions in modern art have reached right into the heart of what it means to be a

viewer, to the very extent of endowing this role with the status of an actor, not to say an active combatant. Anyone who is not aware of this radical shift and has not put into practice Duchamp's old adage *ce sont le regardeurs qui font la peinture* (it is viewers who make painting) will have trouble getting to grips with the art in question. (Trini, 1971, in Christov-Bakargiev, 1999, p.204)

Roles, including that of the critic, had lost their former fixity and were subject to the fluidity and instability that were 'contaminating art by opening it up to the broadest area of aesthetic experience' (ibid., p.204). Trini reconsidered earlier work in the light of what could be called the paradigm shift associated with Conceptual art: 'It seems to me that the current outlook now gives greater significance to two bodies of work which, though underestimated at the time, were extremely prescient. I have in mind the works in Plexiglas exhibited by Pistoletto in 1964 and the exemplary procedures of Giulio Paolini's entire oeuvre going back to 1961' (Trini, op. cit., p.204). For Trini, Pistoletto and Paolini effectively prepared the ground for a second wave of artists that included Prini, Anselmo, Zorio, Boetti and Penone.

The gallerist Antonio Tucci Russo has intriguingly referred to Arte Povera as 'intellectually Conceptual and emotionally Italian'. Arte Povera was certainly part of a wider movement, and its duration (1967–72) coincided with the 'six years' of the 'dematerialisation of the art object' described by Lucy Lippard. However, it developed within the historical context of Italian and European culture; in Christov-Bakargiev's words, 'It is this free and constant dialogue with a past culture that distinguishes Arte Povera from other movements from the second part of the 1960s such as Conceptual art, Land art, postminimalism and antiform, and from slightly later movements such as body and performance art.' Such an attitude was in sharp contrast for example with that of the Land artist Robert Smithson whose *Asphalt Run* 1969 can be seen, in part, as a negation of that history. It was hard, he told Gianni Pettana, to find suitable sites in Europe for making works because 'everything is so cultivated in terms of Church or aristocracy' (Flam, 1996, p.297). The Arte Povera artists, on the other hand, tended to favour a pragmatic eclecticism that included the incorporation of materials and signs belonging to an earlier time, whether it was the colours of Byzantine mosaics adopted by Calzolari or the iconographic motifs found in the work of Fabro or Paolini. Italy's past also provided a ready-made context for an inquiry into the nature of art and the identity of the artist.

The critic Angela Vettese referred to Paolini, Boetti, Pistoletto and Prini as the more cerebral or conceptual artists among the Arte Povera group (as distinct from the materials-oriented Zorio, Anselmo and Penone), though this distinction is by no means absolute. There is also good reason to take them as a subset of Arte Povera in that reciprocal influences can be detected in their work. Boetti, for example, might not have been much interested in the artists preoccupied with energy, but he did study the work of Pistoletto and Paolini with great care.

'AS IF I MYSELF WERE A MIRROR': MICHELANGELO PISTOLETTO

Michelangelo Pistoletto was brought up in a house in which he was surrounded by Renaissance and Baroque pictures. His father was a well-known restorer in

Turin and the young Pistoletto (whose first name suggests great expectations) helped him in his studio. Then, aged twenty-three, he went to learn about advertising at the agency run by Armando Testa, one of the most inventive graphic designers in Italy. It was a formative moment as Pistoletto recently recollected: 'On the ideal map that represents the territory of my participation in the world, the name of Armando Testa is highlighted in a special colour, the one that marks the turning-points. It precisely shows a moment of transition –

a transition from antiquity to modernity'. However, within a year of running his own agency, Pistoletto had decided to work full time as an artist. He went on to pursue an open-ended process of experimentation that would be a decisive influence on the emergence of the new art that became known as Arte Povera. As a close advisor to Sperone and collaborator with Celant, his roles included those of critic, curator and theatrical performer as well as artist – or, rather, his work as an artist encompassed these different activities.

In Pistoletto's case, the metaphor of the 'role' is especially appropriate. On the one hand, his work embodied the hybridity associated with theatre that was so disparaged by defenders of Modernist purity such as Michael Fried. On the other, from the 1960s on, Pistoletto continually returned to the problem of identity – not as the essence or delimited property of a person or thing, but as a process. That process was, moreover, often conceived in his work in terms of multiplication and division. For Pistoletto, the artwork was not the expression of an inalienable individuality but the means to objectify existence, whether his own or that of other things or people, as part of a continuum in which the viewer as well as the artist was an actor.

43
Michelangelo Pistoletto
Marzia with Child
1962–4

Installation at Galleria Gian Enzo Sperone, Turin, 1964
Collection Ileana Sonnabend, New York

Mirrors and reflecting surfaces have been used for centuries by artists as devices 'for thinking with'. In the early 1960s, Fabro, for example, extended his exploration into the spatial dimension with *Hole*. For Pistoletto, as he told Michael Craig-Martin: 'the continual breaking up and renewing of the mirrored forms, their mutations and transformations, the incessant changing, became the parameters of the fourth dimension: time' (Craig-Martin, 1991). Take *Marzia with Child* 1962–4 (fig.43). To a sheet of polished stainless steel measuring eighty-seven by forty-seven inches, Pistoletto glued the life-size image of his wife and daughter. This image was produced by blowing up a photograph, cutting out the silhouette of the figures, and then tracing it onto onionskin paper with oils and pastels to achieve a flat and indistinct effect. The elaborate process is worth detailing because it draws attention to the different media employed, from the photograph to the painting to the mirroring surface

44
Michelangelo Pistoletto

Minus Objects 1965–6

Installation at the
artist's studio, Turin,
January 1966
Mixed media
Dimensions variable
Courtesy Pistoletto
Foundation, Biella

itself. It shows, in Claire Gilman's words, that 'far from championing the simplicity of elemental materials and gestures', works such as this 'deal in artifice, narrative and theatricality' (Gilman, 2001, p.11). The viewer 'enters' the intimate space occupied by mother and child (fixed in the photograph) that is temporally connoted as time-past. At the same time, he or she is standing and looking in the real space of the gallery, which is reflected in the picture as an ever-changing present.

The mirror pictures had their origins in self-portraits inspired by the paintings of Francis Bacon, but Pistoletto's inquiry into identity led outwards into the space of his studio and everyday life. His next move was to make three-dimensional objects that were conceived as unrepeatable and isolated actions, his *Minus Objects* 1965–6 (fig.44). In his working notes, he wrote:

They are minus objects in so far as they are detached from me as a unitary being. The operation started with a rational presupposition but it was achieved by fixing elements that arose in the unconscious. With these works I am trying to establish myself as a mediator between the physical reality outside and the immaterial one of my intimate self, as if I myself were a mirror that reflects the two parts of myself. (Pistoletto, 1976, p.20)

Pistoletto was thereby freeing himself from the pressure to produce works in the style or manner of 'Pistoletto'. The artist, who at the time was sharing his studio/living space with members of Living Theatre, developed a practice similar to theirs, that Celant was later to call *libero progettarsi*. By this he meant working with total openness to contingency and everyday experience. When a photograph of Jasper Johns came back from the developers with the ear cropped off, Pistoletto blew up the image and included it among the *Minus Objects* (the ears, taken from other photograph meanwhile, were put on the wall separately). When he noticed how after the opening of a show the walls were marked in the places where people had leant, he made *Structure for Talking while Standing* 1965–6, comprising a metal rail with cross-bar on which one could rest one's foot. Another of the *Minus Objects*, *Cubic Metre of Infinity*, derives from Pistoletto's earlier work using mirror surfaces. But this time they are turned to face one another. As a consequence, an infinity of reflections is produced, though these can only be conceived in the mind of the viewer as the object itself is utterly impenetrable.

PISTOLETTO

ROMA · DAL 12 FEBBRAIO AL 12 MARZO 1968

L'ATTICO

45
Poster designed by Michelangelo Pistoletto for his solo exhibition at the Galleria L'Attico, Rome 1968

46
Maria Pioppi during a performance by Zoo at Vernazza, 1968

Martin Friedman, who curated a solo show dedicated to Pistoletto's mirror paintings in Minneapolis in 1966, noted that there were strong parallels between the artist's work and contemporary developments such as the 'happening', with its 'active utilisation of surroundings in which the audience becomes the vitalising element'. 'While he has never participated in a happening', writes Friedman, 'he is strongly interested in generating a spontaneous event which occurs as the observer enters the picture' (Friedman, 1966). Many experimental currents at the time, from the avant-garde grouping Fluxus to the music of composer John Cage and Living Theatre, introduced freedom of movement between 'art' and 'life' and performativity into the visual arts. In Cage's words, his music was 'purposeless play', an affirmation of life – not an attempt to bring order out of chaos, nor to suggest improvements in creation, but simply to make up the very life we're living' (Godfrey, p.63). Pistoletto's actions were, therefore, both a logical extension of his practice and a response to an environment in which media were being mixed and

manipulated in new ways. The use of the studio as a place for observing and analysing his own behaviour led Pistoletto to conceive of himself as the viewer of his own work. For his solo show at the Attico gallery in Rome in 1968, he took this a step further. The artist issued a few simply instructions and then joined the viewers in following them: costumes from the film studio of Cinecittà were provided on rails and spectators were invited to dress up and to move freely under 1,000-watt stage lights in a space furnished with the odd prop and some mirror paintings on the walls. The gallery was, in art historian Maria Teresa Roberto's words, 'turned into a cross between a stage and a cinema set, and the visitors were invited to play the role of walk-on parts and observers

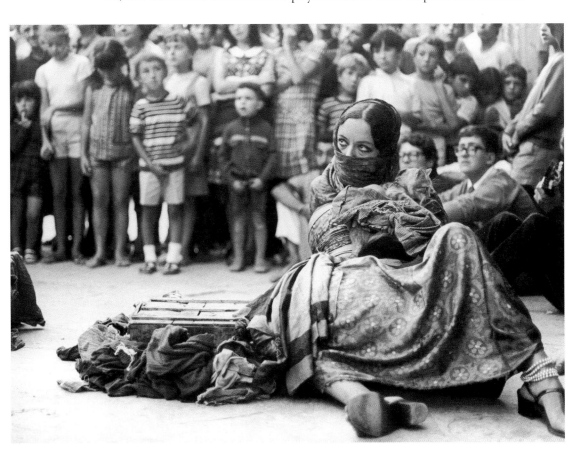

and to explore, as Pistoletto said, "the limits dividing the self from one's surroundings, the choreography of the self"'. The poster for the exhibition (fig.45) shows Pistoletto wearing a floral hat in the manner of James Ensor, the Belgian artist famed for his masks and masquerades, who had, in turn, been 'quoting' a Rubens self-portrait.

Between 1968 and 1971 Pistoletto threw himself into the activities of Zoo, a performance group that he set up with a number of others, including his partner, Maria Pioppi, the critic Henry Martin and the Milanese actor Carlo Colnaghi. Crucially, Zoo was a collective and egalitarian initiative that aimed

to take performances into the streets and piazzas of towns and villages (fig.46), such as that of Amalfi, in a manner reminiscent of the strolling players and artistic nomads of the past. As such, it had more in common with Living Theatre in its desire to involve audiences as actors than it did with Grotowski's highly specialised conception of theatre. Meanwhile, the outlandish garments of Zoo were echoed in the colourful works using rags that Pistoletto had made

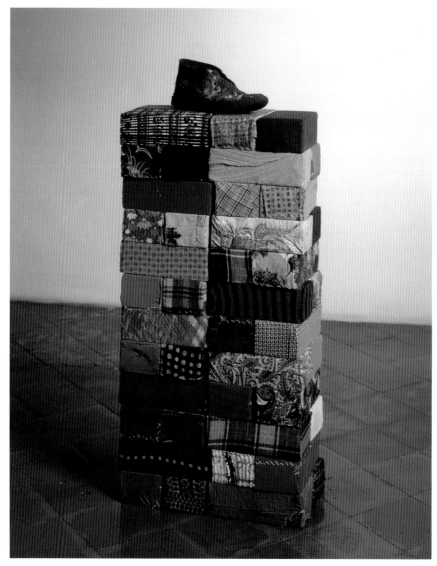

47
Michelangelo Pistoletto

Monumentino
(Little Monument)
1968

Bricks, rags, shoe
100 × 40 × 40
(39⅜ × 15¾ × 15¾)
Private Collection

48
Alighiero Boetti

Nothing to See, Nothing to Hide 1969

Iron and glass
300 × 400 × 4
(118⅛ × 157½ × 1⅝)
Private Collection,
London

his trademark (fig.47). These rags, initially discovered by Pistoletto at Prato, the centre of the Italian second-hand clothing business, communicated a spirit of disorder and vitality rather than impoverishment. The message of Zoo was clear: escape from the cages that you inhabit – live.

'I AM I, HE IS HE': ALIGHIERO BOETTI

'I, the world, things, life, we are situations of energy.' (Giovanni Anselmo)
'I'd like to let it be known that I love a ball of paper, the igloo, shoes, fine thread, fern, the chirping of the cricket.' (Pier Paolo Calzolari)
'I have prepared a series of hypothetical actions.' (Emilio Prini)
'The conditions for a passionate life existed, but I had to destroy them to be able to recuperate them.' (Alighiero Boetti)

All the above are the opening lines of statements (or in Boetti's case, the entire statement) published in *Arte Povera* in 1969. They remind us that words, along

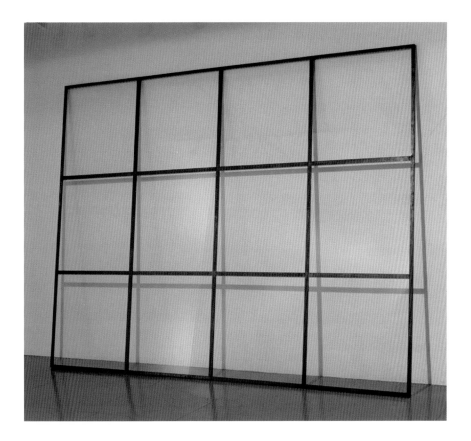

with numbers, proliferate in Arte Povera. In Celant's book they exist in parallel with the work; in the artworks, they are written in neon by Mario Merz and Calzolari, or hammered into solid materials and spoken through fluids by Zorio. As titles, words are of decisive importance to Paolini. The statements also remind us of the centrality of subjectivity in Arte Povera. The artists use the first person when speaking of their relationship to the world, of their actions (real and hypothetical), or of their ideas of identity. But the artists seek to explore and analyse subjectivity, not to express it.

For Alighiero Boetti, in particular, language was crucial in the development of his art practice. As we saw at the beginning of this essay, works like *Manifesto*

(figs.1 and 2, pp.7–9) employed a system of signs as part of a discourse *about* signs. The idea, pivotal to structuralist thought, that the relationship between language and 'reality' is arbitrary (i.e. that language is not transparent) and that there are 'deeper structures' that order and classify the world in the manner of language, greatly influenced Boetti along with others of his generation. Exemplary in this respect was the rivers project, begun in 1970 with his partner Anne-Marie Sauzeau, which consisted of classifying the thousand longest rivers in the world. What they found was that the names of rivers and their physical reality seldom corresponded; lengths varied according to source of information, season and a multitude of other variables. Classifications purporting to be scientific and to describe an objective reality 'would always be provisional and illusory'. As Maria Teresa Roberto writes in relation to *Nothing to See, Nothing to Hide* 1969 (fig.48), Boetti is providing an antidote to the idea of art as a window onto the world or into the soul; like language, it hides and reveals at the same time (Roberto, 1996, p.30).

Of all the artists of Arte Povera, Boetti is perhaps the most difficult to pin down. This is not least because of the 'incessant search for new territories' and 'non-linear method and modality of thought' that Ammann has identified in his work, likening him to Bruce Nauman (Ammann, 1996, p.21). However, there are procedures developed and applied by Boetti in line with LeWitt's proposition 'the idea becomes a machine that makes the art' that recur in his work (Lippard, p.28). One of these was 'doubling'. When Mirella Bandini noted the use of doubling in works from *Ping Pong* 1966 (fig.49) through to *Twins* 1968 (fig.50) and *Contest Between Harmony and Invention*, the work of 1969 made by retracing squares of graph paper by hand, Boetti acknowledged the recurrence: 'Tautology is always double ... Yes, doubling is tautology too ... I am I, he is he.' He then recounted the incident that had led him even to double his own self by adding the word 'and' between his first and second name:

49
Alighiero Boetti

Ping Pong 1966

Wood, glass, electrical
components
Two parts, each:
50 × 50 × 20
(19⅝ × 19⅝ × 7⅞)
Goetz Collection,
Munich

50
Alighiero Boetti

Twins 1968

Mixed media on paper
and postcard
Edition of 50
15 × 10 (5⅞ × 3⅞)
Courtesy Boetti Archive,
Rome

'Alighiero e Boetti' is the simplest: you just put 'and' between the two names. It has to be theatrical. I remember one day I'd done a drawing. I'd signed it 'Alighiero e Boetti'. A woman I didn't know came into the studio and said, 'Who are these two people?' Everything was right. These little things confirm reality. (Bandini, 1972, in Flood and Morris, 2001, p.189)

The use of tautology was a defining trope of Boetti's work in the first Arte Povera show; interestingly *Nothing to See, Nothing to Hide* was originally called *Large Glass Window*. However, while maintaining its linguistic emphasis, Boetti's work departed from the original project of reducing the language of art to the barest elements. His use of doubling introduced elements of mystery and enigma that recalled the mirrored world of Pistoletto. Alberto Boatto describes the photomontage, *Twins*: 'along a tree-lined avenue which functions as a pathway for time, we see Boetti coming towards us both as one and two, the original and the replica, the person and the double, the individual and the simulacrum, the adult Narcissus and the beloved reflection, Alighiero and Boetti, affectionately hand in hand' (Boatto in Christov-Bakargiev, p.240). The use of photography

in *Twins* enabled him to duplicate and make the image into postcards that he sent to friends. The technology of doubling was also integral to his work using a Xerox machine (the latest innovation at the time). In *Nine Xeroxes Anne-Marie* 1969 the image of Boetti's face is accompanied by hand gestures that signify the letters ANNE-MARIE in sign language. Here we have a self-portrait of the artist undergoing a reversal reminiscent of Paolini's *Young Man Looking at Lorenzo Lotto* (fig.15). Certainly the mimetic function of the image is rendered problematic by the addition of the name Anne-Marie.

In *Today is Friday 27 March 1970* 1970 the title is the work and work is the title. Boetti uses left and right hand to write the words on the wall. The double action is redoubled because the writing to the left mirrors that to the right and vice versa. The action, filmed by Gerry Schum, is a remarkable feat of co-ordination of body and mind in which one person has done the work of two. Boetti stages the work as if he were both himself and other than himself. In a haunting photograph reproduced in the catalogue of *When Attitudes Become Form*, Boetti is lying on the ground next to an oval stone with the imprint of his face carved into it; positive and negative, convex and concave, life and death lie side by side (fig.51). Here the reversed death mask introduces the idea of the passage of time, a theme that becomes increasingly important for Boetti. In 1971, he even made a work, *11 July 2023 – 16 December 2040* (fig.52), in which the date of his presumed death and the date of the 100th anniversary of his birth were woven in embroidery. (Sadly, Boetti died in 1994, some twenty-nine years before he had predicted.)

51
Alighiero Boetti

Self-Portrait in Negative
1968

Sculpture in stone
Dimensions and
whereabouts unknown

Commentators have sometimes suggested that Boetti left Arte Povera behind him after a brief infatuation with materials and object-making. Anne-Marie Sauzeau, for example, writes: 'for Boetti Arte Povera was a festival lasting three years (1966–8) and no longer. Time enough for a joyful exploration of workshops, stores, and flea markets – those Ali Baba caves where Alighiero was filled with wonder and amazement' (Sauzeau, 2001, p.40). Boetti himself recalled: 'There had been too much focus on materials ... I remember in the spring of 1969 I left the studio which had become a warehouse full of asbestos lumber, cement, stones. I left everything as it was and started again from scratch, with a pencil and a sheet of paper.' However, this interpretation is based on the assumption that Arte Povera was a set of art practices concerned principally with the properties of materials. It also implies that there was a common style or collective identity that was becoming oppressive for the individual artist. The fact that Boetti had participated in every show from the beginning and continued to be involved until the very last exhibition suggests a different story. Of all the artists, Boetti loved the ping-pong of discussion and exchange: 'I always found new work, whether ugly or beautiful, that was strong. Even if I didn't enter into dialogue with it, things came out all the same.' His work can be read as a continuous conversation with

52
Alighiero Boetti
11 July 2023 –
16 December 2040
1971
Embroidery on canvas
Two parts, each:
60 × 60 (23⅝ × 23⅝)
Private Collection,
Houston

that of other artists, whether Pistoletto's *Minus Works* or Paolini's studies using photography. His work *AB:AW=MD:L* 1967 (fig.53) is an ironic *hommage*: Alighiero Boetti:Andy Warhol=Marcel Duchamp:Leonardo. His ability to mimic and sometimes mock the work of others could irritate and even infuriate. Boetti's reaction against the 'cult of materials' can be understood, therefore, as part of a dialogue rather than as a decision to quit the group to

which he owed so much. The real break for Boetti occurred when he went to Afghanistan for the first time in March 1971 and when the following year he left Turin and moved to Rome. Arte Povera had always been a dialogue within the European tradition and between Italian artists and their American counterparts. When Boetti moved beyond these confines he opened the door to a quite different tradition and took a step that anticipated the development of art with a more global outlook in which the learning and use of new languages was one of the defining features.

53
Alighiero Boetti
AB:AW = MD:L 1967
Silkscreen print
modified by the artist
59 × 59 (23¼ × 23¼)
Collection Gian Enzo
Sperone, New York

5

AFTER ARTE POVERA

Richard Long, speaking at the time of the show *Zero to Infinity: Arte Povera, 1962–72* (held at Tate Modern in 2001), recalled the Amalfi events of 1968 and the whole Arte Povera experience:

I just thought I would go and check it out. I had no idea what was going on. I got off the train and found myself in this strange environment; it was like falling into a world of a travelling troupe of circus people. You have to remember that the prevailing dogma was American art, and that art of the time was Minimalism. It was only years later that I began to realise that this was the beginning of Arte Povera. Britain was very isolated then – we had parochial figures at St Martin's like Anthony Caro – and Arte Povera was completely unknown except to a handful of people. The spirit of Arte Povera was much more free and relaxing to make work in: more intuitive, more open-ended, more off the cuff, more lackadaisical, the polar opposite of Minimalism. To me it was a breath of fresh air. (*Independent on Sunday*, 30 May 2001)

Three things in Long's remarks are worth noting. Firstly, the Italian art scene at the time was on the edge of the known world for a London-based artist and had to struggle to compete for attention with the growing presence of American art. Secondly, the Italians were extremely open and experimental – so much so that they were far from being provincial in their readiness to take in and adapt ideas from any quarter (hence the speed with which American Conceptual artists and British artists such as Gilbert and George and Long himself were understood in Italy). Thirdly, it took a long time (perhaps not until the 1980s) for the significance, and hence influence, of Arte Povera to be recognised. Even Long, it seems, did not realise until

much later how important this new Italian art was for the future.

The *Guardian* critic Adrian Searle commented on the major retrospective show: 'Walking through the Tate Modern, it is impossible not to think of artists from around the world whose work has been informed by what at first appeared a local, northern Italian phenomenon. Make your own list: from Sarah Lucas to Miroslaw Balka, from Cildo Meireles to Imi Knoebel, from Gabriel Orozco to Damien Hirst' (*Guardian*, 29 May 2001).

Many other artists and examples of artwork could be discussed in relation to the influence of Arte Povera. If one just takes Britain from the early 1990s, one could cite Mona Hatoum and her subversion of the Minimalist object, Marc Quinn and his exploration of materials in conjunction with his own body, Tony Cragg and his 'poetic' assemblages, or Anya Gallaccio and her use of trees. When Quinn, for instance, speaks of his methods of working, his delight in paradox ('I love taking very heavy material and making it as light as air'), and his desire to go beyond conventions to create art that is about 'reality', he could be echoing attitudes and ideas that come straight from Zorio, Anselmo or Penone.

The 2001 exhibition, jointly curated by Richard Flood of the Walker Art Center and Frances Morris of Tate Modern, toured the United States, providing not only an exceptional opportunity to see the work but also a kind of official recognition of its importance within the English-speaking world. However, the influence of Arte Povera is easier to note 'in general' than to explore in detail. Arte Povera, as has been argued, combined very different practices under one umbrella. An interesting case for further study is Gabriel Orozco, the Mexican artist, whose practice has affinities with those of Arte Povera and who sometimes playfully quotes their work.

Orozco apparently 'feels uncomfortable being inserted into the genealogy of Arte Povera' (Ruiz, 2000, p.52). If one equates Arte Povera simply with a certain use of materials, he is right. But if it is taken in its more conceptual and poetic sense, then Orozco has produced works that share a certain spirit and approach with artists such as Boetti, Pascali and Pistoletto. Alma Ruiz has written of 'his fondness of recording daily life, the relationship of objects to his own body, and his ongoing interest in movement' and of a 'practice that favours unexpected associations and conceptual links over formal ones' (ibid., pp.25-6). Orozco, moreover, celebrates the qualities of bricolage and inventiveness that is perhaps characteristic of a country (in his case Mexico) that is peripheral to the world's technological and economic centres. At least two of his works seem to have been inspired by Arte Povera: his *Parking Lot* 1995 (fig.54), for example, consisted of turning the Galerie Micheline Szwajcer in Antwerp into a temporary parking space for the duration of the exhibition – a kind of 'allegorical sublation' (Benjamin Buchloh's words) of Kounellis' installation in the Attico gallery using horses. The second work is *Yielding Stone* 1992, a sphere of grey plasticine, the same weight as the artist, that Orozco rolled down the streets of New York. It recalls Pistoletto's *Ball of Newspapers* 1966, one of the *Minus Objects* that he rolled through the streets of Turin in 1967. But more important than citation or homage is the real affinity between Orozco's artistic strategies and those of the earlier generation of Italian artists:

the economy of gestures and materials, the engagement of the viewer in forceful questioning, the importance of wit and playfulness, and the rigour combined with appetite for accident and improvisation.

This essay has attempted to go back to the roots of Arte Povera, looking beyond subsequent accretions and offering new perspectives. In the decades since it was a contemporary reality, Arte Povera has been continuously plundered for ideas by artists and re-interpreted by curators and art historians. Significantly, most of the original artists have continued to produce new work and to exhibit internationally under the title Arte Povera, often in collaboration with Celant himself. It would seem that, 'for their part, the artists realized that they had everything to gain from exploiting the brand "Arte Povera", even if they had become skeptical as to its applicability' (Lumley, 2004). Any serious discussion of the influence of this art should, therefore, take into account how

54
Gabriel Orozco

Parking Lot 1995

Installation shot,
Galerie Micheline
Szwajcer, Antwerp
Coutesy of Marian
Goodman, New York

Arte Povera has assumed new and even contradictory meanings. The value of returning to the original body of work is that it was the product of an exceptional moment – a moment when a critical mass of artists worked in a situation of intense dialogue, extraordinary experimentation and great openness. Such an experience is rare and formative. As Alighiero Boetti recalled: 'you always get going as part of a group. The great schools are always born from a group of people who get worked up, excited, overheated. Then everyone follow their own path, each becoming more precise, defined and right for that person' (Bandini in Flood and Morris 2001, p.190). For all the disputes over the term 'Arte Povera', it was this collective dimension that ultimately loosened the individual talent and ideas of the single artists, making it one of the most radical and influential movements of the late twentieth century.

BIBLIOGRAPHY
*Sources of quotations and
further reading*

Relatively little is published in
English on Arte Povera. There is
much more in French and
German. My own work is based
extensively on Italian written
sources, not to mention
interviews with artists, gallerists,
critics and collectors. The key
source in English is the excellent
work *Arte Povera* by Carolyn
Christov-Bakargiev, published
in 1999. The list below, divided
into books on Arte Povera
generally and books on
individual artists, indicates
publications that I found
particularly useful.

Arte Povera and its context

Ammann, Jean-Christophe,
'Visualized thought
processes. The young Italian
avant-garde', in Christov-
Bakargiev 1999

*Arte Povera from the Goetz
Collection*, Munich 2001

Bachelard, Gaston, *The Poetics
of Space*, Boston 1969 (first
published 1958)

Banham, Reyner, *Theory and
Design in the First Machine Age*,
London 1999 (first
published 1960)

Batchelor, David, *Minimalism*,
London 1997

Beeren, Wim, 'Op losse
schroeven' in *'60 – '80 A
Selection from 20 Years of Visual
Arts*, exh. cat., Amsterdam
1982

Cameron, Dan, 'L'arte povera
è Americana?', *Flash Art*,
no.168, June/July 1992

Celant, Germano (ed.), *Arte
Povera*, Milan 1969; published
in English as *Art Povera:
Conceptual, Actual or Impossible
Art?*, London and New York
1969

Celant, Germano,
Precronistoria, 1966–69,
Florence 1976

Celant, Germano, *Art Povera,
Arte Povera*, Milan 1985

Christov-Bakargiev, Carolyn
(ed.), *Arte Povera*, London
1999

Criticos, Corinna, 'Reading
Arte Povera', in Flood and
Morris 2001

Crow, Thomas, *The Rise of the
Sixties*, London 1996

Eco, Umberto, *The Open Work*,
trans. Anna Cagnoni,
Cambridge, Mass. 1989 (first
published in Italian in 1962)

Flam, Jack (ed.), *Robert
Smithson: Collected Writings*,
Berkeley 1996

Flood, Richard and Frances
Morris (eds.), *From Zero to
Infinity, Arte Povera 1962–72*,
exh. cat., Walker Art Center,
Minneapolis and Tate
Modern, London 2001

Gianelli, Ida (ed.), *Arte Povera
in Collection*, exh. cat., Castello
di Rivoli, Milan 2000

Gilman, Claire,
'Reconsidering Arte Povera',
in *Arte Povera. Selections from the
Sonnabend Collection*, New York
2001

Giddens, Anthony, *The
Consequences of Modernity*,
Cambridge 1990

Godfrey, Tony, *Conceptual Art*,
London 1998

Grotowsky, Jerzy, *Towards a
Poor Theatre*, London 1991

Humphreys, Richard,
Futurism, London 1999

Kaye, Nick, *Site-Specific Art*,
London 2000

Lippard, Lucy, *Six Years: The
Dematerialization of the Art
Object from 1966 to 1972*,
Berkeley 1997

*Live in Your Head. When Attitudes
Become Form*, exh. cat.,
Kusthalle, Bern, and ICA,
London 1969

Lonzi, Carla, *Autoritratto*,
Milan 1969

Lumley, Robert, 'Between
Pop Art and Arte Povera:
American Influences in the
Visual Arts in Italy in the
1960s', in Passerini, Luisa
(ed.), *Across the Atlantic:
Representations and Cultural
Exchanges, 1800–2000*,
Brussels 2000

Lumley, Robert, 'Spaces of
Arte Povera', in Flood and
Morris 2001

Lumley, Robert, 'Turin after
Arte Povera: A new city of
art?', in R. Lumley and J.
Foot (eds.), *Italian Cityscapes*,
Exeter 2004

Merleau-Ponty, Maurice,
The Phenomenology of Perception,
trans. Colin Smith, London
2000

Minola, Anna et al, *Gian Enzo
Sperone: Torino, Roma, New York.
35 anni di mostre tra Europa e
America*, Turin 2000

Newman, Amy, *Challenging
Art: Artforum 1962–1974*,
New York 2000

Roberto, Maria Teresa,
'Davanti allo specchio, al di
qua delle sbarre. Lo Zoo e i
suoi antefatti, 1966–70', in
*Galleria Civica dell'Arte Moderna
e Contemporanea*, Turin,
forthcoming

Rorimer, Anne, *New Art in the
60s and 70s: Redefining Reality*,
London 2001

Ruhrberg, Bettina, 'Arte
Povera. The genesis of a term
and the reception of a
"movement"', in *Arte Povera
from the Goetz Collection*, 2001

Thompson, Jon, 'New
Times, New Thoughts, New
Sculpture', in *Gravity and
Grace. The Changing Condition of
Sculpture, 1965–75*, exh. cat.,
Hayward Gallery, London
1993

Trini, Tommaso, 'New
Alphabet for Body and
Matter' (1969), in
Christov-Bakargiev 1999

Trini, Tommaso, 'Arte
Povera, Land Art,
Conceptual Art' (1971), in
Christov-Bakargiev 1999

Vettese, Angela, *Capire l'arte
contemporanea*, Turin 1998

Artists
(in alphabetical order, by artist)

Ammann, Jean-Christophe, 'Giovanni Anselmo' (1979), in Christov-Bakargiev 1999

Lugli, Adalgisa, 'Giovanni Anselmo', in *Giovanni Anselmo*, exh. cat., Galleria Civica Modena, Turin 1989

Meinhardt, Johannes, 'Signs of a Fluid World: Giovanni Anselmo's Indices of Energy Processes', *Arte Povera in the Goetz Collection*, Munich 2001

Ammann, Jean-Christophe, Maria Teresa Roberto and Anne-Marie Sauzeau, *Alighiero Boetti, 1965–94*, Milan 1996

Boatto, Alberto, 'Aligiero Boetti' in Christov-Bakargiev 1999

Bandini, Mirella, 'Alighiero Boetti: Interview' (1972), in Flood and Morris 2001

Roberto, Maria Teresa, 'Alighiero Boetti 1966–70, le parole e le cose', in Ammann 1996

Sauzeau, Anne-Marie, *Alighiero e Boetti. Shaman/Showman*, Turin 2001

Tarsia, Andrea (ed.), *Alighiero e Boetti*, exh. cat., Whitechapel Gallery, London 1999

David, Catherine, 'Particolari: la poetica allegorica di Pier Paolo Calzolari', in I. Gianelli (ed.), *Pier Paolo Calzolari*, Milan 1994

Zacharapoulos, Denys, 'The Nomad carries his home permanently inside himself. An interview with Pier Paolo Calzolari', in *Arte Povera in the Goetz Collection* 2001

de Sanna, Jole, *Luciano Fabro: Biografia Eidografia*, Parsian di Prato 1996

Morris, Frances, *Luciano Fabro*, London 1997

Vertone, Saverio, 'Fabro' (1971), in de Sanna 1996

Jacob, Mary Jane (ed.), *Jannis Kounellis*, exh. cat., Museum of Contemporary Art, Chicago 1986

Moure, Gloria (ed.), *Jannis Kounellis. Works, Writings, 1958–2000*, Barcelona 2000

Celant, Germano, *Mario Merz*, exh. cat., Solomon R. Guggenheim Museum, New York 1989

Ducros, Francoise, *Mario Merz*, Paris 1999

Bandini, Mirella, 'Marisa Merz: Interview' (1972), in Flood and Morris 2001

Fuchs, Rudi, 'Marisa Merz', in Grenier 1994

Grenier, Catherine (ed.), *Marisa Merz*, Paris 1994

Castagnoli, Pier Giovanni and Danilo Eccher (eds.), *Marisa Merz*, Turin 1998

Trini, Tommaso, 'Marisa Merz et histoire du travail', in Grenier 1994

Buchloh, Benjamin, 'Gabriel Orozco: The Sculpture of Everyday Life', in Ruiz 2000

Alma Ruiz (ed.), *Gabriel Orozco*, exh. cat., Museum of Modern Art, Los Angeles, and Museo Internacional Rufino Tamayo, Mexico City 2000

Stephen Bann, 'Giulio Paolini' in M. Newman and J. Bird (eds.), *Rewriting Conceptual Art*, London 1999

Celant, Germano, *Giulio Paolini*, New York 1972

Fagiolo, Maurizio, 'Giulio Paolini' in Arturo Carlo Quintavalle and M. Fagiolo, Parma, 1976

Giulio Paolini, exh. cat., Museum of Modern Art, Oxford and Stedelijk Museum Amsterdam, 1980

Lonzi, Carla, 'I pretend to make sculptures. Interview with Pino Pascali, 1967', in *Arte Povera from the Goetz Collection*, 2001

Pino Pascali, exh. cat., Musée d'Art Moderne de la Ville de Paris, 1991

Pino Pascali, exh. cat., IVAM Centre Julio Gonzalez, Valencia 1992

Celant, Germano, *Giuseppe Penone*, Milan 1989

Gianelli, Ida and Giorgio Verzotti (eds.), *Giuseppe Penone*, exh. cat., Galleria Civica di Arte Contemporanea, Trento 1997

Schreier, Christoph, 'The form of the tree is its memory. Interview with Giuseppe Penone', in *Arte Povera from the Goetz Collection*, 2001

Celant, Germano, *Pistoletto*, New York 1989

Pistoletto, exh. cat., Palazzo Grassi, Venice 1976

'Michael Craig-Martin, in conversation with Michelangelo Pistoletto', *Michelangelo Pistoletto: Minus Objects, 1965–66*, exh. cat., Camden Arts Centre, London 1991

Friedman, Martin, 'Michelangelo Pistoletto', in *Michelangelo Pistoletto: A Reflected World*, exh. cat., Walker Art Center, Minneapolis 1966

Malsch, Friedemann, 'The Paradox of Presence. Attempting to Fathom Emilio Prini', *Arte Povera in the Goetz Collection* 1999

Marc Quinn, exh. cat., Tate Liverpool 2002

Bandini, Mirella, 'Gilberto Zorio: Interview' (1972), in Flood and Morris 2001

Merz, Beatrice, and D. Zaccharopoulos, *Zorio*, Ravenna 1982

COPYRIGHT CREDITS

PHOTOGRAPHIC CREDITS

INDEX